天工 當代工藝的百工百貨
MASTERPIECES : CONTEMPORARY CRAFTS COLLECTION

天 工 開 物 ， 匠 心 實 足

序／PREFACE

創生一座臺灣的當代故宮

「工藝」根著於土地、氣候、民俗、生活習慣而成。
「工藝」無分新舊更迭，須與時俱進，且融入生活。

　　為提供工藝職人更優質的展演場域，裨益民眾親近工藝與作品互動，本中心臺北分館於 2015 年 11 月喬遷至臺北市南海學園內仿天壇形式建築的「國立臺灣科學館」舊址，重新活化再利用古蹟建物，並定位為「臺北當代工藝設計分館」。以展現臺灣在地與國際當代工藝設計趨勢、推展文化傳承與教育新知、宣揚臺灣當代工藝發展、扶植青年工藝新秀、行銷推廣臺灣工藝設計精品並促進產業升級為積極目標。

天工開物，巧奪天工

　　「工藝」代表一個時代的文化內涵與文明深度與廣度，放眼全球知名的博物館，莫不典藏當代經典的作品。臺灣工藝品質水準高，作品善於保留傳統元素並融合質感，呈現當代時尚設計，具有名列全球前五名的軟實力。故本中心期望透過展演，提升臺灣當代優質工藝作品的能見度，並促進國內外交流的曝光率，積極拓展與國際接軌合作的機會。

　　「臺北當代工藝設計分館」以成為「臺灣當代故宮」自我期許，要讓當代最好的工藝作品有一個完善的展演空間與創生的舞臺。換言之，能被本分館展出的工藝品，無庸置疑都將是臺灣當代最好的工藝作品。目前臺灣工藝師精湛的表現已經受到全球買家的青睞與關注，包括英、法、德、義及以色列等國家級的博物館紛紛前來打探作品消息，本中心將持續引領設計風潮，扶植工藝師創生臺灣當代精良的工藝品，成為世界各國國家級博物館爭相典藏的當代工藝作品！

　　本中心希冀讓更多人見識到臺灣當代職人「巧奪天工」的精湛手藝，也呼應《天工開物》一書尊重多元、積極探索研究各類工藝的精神，因此，本館喬遷後的首展主題特命名為「天工」，旨在呈現臺灣當代經典工藝作品與工藝創作趨勢，訴說臺灣當代工藝美學與鑑賞之精髓。

尤其，臺灣工藝師們長年在各自專精的領域默默耕耘，「天工」大展的策展理念之一就是要呈現工藝師們巧奪天工的技術與創意，讓工藝師們發光發熱，引動更多人從深厚的文化底蘊出發，創生出高感質、多創新的時尚精彩。

經典雋永，傳承不朽

職人們長期投注生命於工藝品的製作、技巧的研發、手藝純熟度的提升。他們以追求完美且用心創作的決心，創作出高品質的工藝作品。這些蘊藏著技藝的純粹和溫度、生命和活力的作品，來自職人細微觀察、萃取生活點滴所悉心打造的成果。這次透過「臺北當代工藝設計分館」的展演舞臺，引領時尚潮流的策展理念，不僅成就經典，更展現職人作品歷久彌新的多元風貌。

因此，開館首展結合「百工」與「職人」的頂真精神，呈現「當代工藝的百工百貨」之概念，邀請各領域工藝師跨世代參與展出，展區分為「天工職人」主題區與「工藝大觀」物意區，展現經典雋永與創新多元的工藝饗宴，精選出具有經典藝術作品與原創系列的代表性創作，希望搭起「產業與工藝」、「商業與藝術」、「經典與創新」之間兼容並存的媒合契機與可能性。

「天工」大展是精湛的「臺灣當代工藝技術」集大成之展，更是「臺灣工藝創作能量的累積」，同時傳達「傳承、設計、開創」的三大工藝內涵；透過書寫職人的實踐歷程來訴說工藝品的萬象風情；以懷抱感念的態度禮讚臺灣工藝職人。點滴淬鍊出的作品孕育豐富內涵，傳遞工藝技術之細緻意境、傳承文化的保存發展，處處展現令人驚豔的面貌，並激盪出更多精彩的文化創意動能。

請與我們一同瞭解工藝職人堅毅不朽的精神，探索領略當代工藝之美！

國立臺灣工藝研究發展中心主任　

序／PREFACE

Creating a contemporary "National Palace Museum" in Taiwan

Crafts, rooted in the land, climate, customs and habits of life.
Crafts, separated not by new and old, flow with time, immersed in life.

In November 2015, the Taipei Contemporary Craft Design Branch of the National Taiwan Craft Research and Development Institute (NTCRI) relocated to the former National Taiwan Science Education Centre in the Naihai Academy. The new location has an exterior design based on Beijing's Temple of Heaven and has undergone detailed renovations to restore its essential heritage and to expand its functionality for its new role, providing the Institute's artisans with a superior environment where they can showcase their works. In this new facility the branch will strive to demonstrate contemporary design trends from Taiwan and abroad, to educate the public, to support cultural heritages, to encourage and foster the development of young artisans in Taiwan contemporary craft design, and to promote the marketing and advancement of distinctive Taiwan fine crafts.

Created by nature, crafted by masters

Fine crafts often reflect an era's deep cultural roots and the breadth of its civilization, as we can see from looking at world renowned museums and their abundant collections of contemporary and classical works. In Taiwan's case, its high quality crafts have been particularly good at retaining traditional elements and textures while integrating contemporary design, thereby helping it attain a top 5 ranking worldwide. The institute hopes that through its exhibitions it will be able to enhance the visibility of Taiwan's high quality contemporary craft designs, providing both domestic and international exposure, and actively expanding the number of opportunities to connect, interact, and cooperate around the world.

The Taipei Contemporary Craft Design Branch is set on becoming a modern-day "National Palace Museum" in Taiwan, where the best contemporary craft designs are presented in a unique setting. That is to say, the selected objects displayed will be without a doubt the finest contemporary fine crafts in Taiwan. Already, international museums from the United Kingdom, France, Germany, Italy and Israel have been paying attention to and inquiring about the artisans and fine crafts on exhibit. Going forward, the Taipei branch will continue to take the lead in design trends and will strive to assist and promote Taiwan artisans, helping them gain a place in contemporary fine craft collections in the leading national museums of the world.

The theme of the first exhibition in our new location is "Masterpieces: Contemporary Crafts Collection". It is tied closely to the book "Created by nature, crafted by masters", which advocates respecting diversity in fine crafts and proactively engaging in exploratory research. The exhibition opens the public's eyes to the exquisite designs and techniques of contemporary artisans in Taiwan. It showcases Taiwan's creative fine craft trends, allowing for a greater understanding of aesthetics in Taiwan's contemporary fine crafts.

天工 當代工藝的百工百貨

With this exhibition, specialized Taiwan artisans, who have for many years refined their skills out of the limelight, now have a place to shine and present their extraordinarily creative works. More than ever, people are encouraged to get involved in and be inspired by a culture of innovative artisanship and skill mastery.

Timeless classics, everlasting heritage

To create the highest quality fine crafts, artisans diligently pursue perfection with each new creation. They fully devote themselves to continually developing and enhancing their skills, and are deeply committed to creating works that draw on and embody their detailed and subtle observations, attitudes and life experiences. Their vitality and enthusiastic energy are clearly manifested in their works. So, throughout this exhibition, we can witness not solely traditional achievements, but also new trends being established, and a more pluralistic environment with a timeless future coming into being.

Hence, for this premiere exhibition, we are bringing together the genuine essences of fine crafts and artisans, and inviting artisans from all fields to participate. Divided into two major theme areas, "Master Artisans" and "Fine Crafts Showcase", it presents selected outstanding and representative fine crafts, consisting of timeless classics and innovative creations, in a magnificent feast. Combining often incompatible positions like classical and innovative, business and arts, and industry and craft, it offers up new opportunities and possibilities for novel insights and outlooks.

"Masterpieces: Contemporary Crafts Collection" is a superb exhibition showcasing the full spectrum of Taiwan's contemporary fine crafts, and channeling the accumulated creative energy into the three themes - heritage, design and innovation. The copious magnificence of crafts are depicted through the portray of artisans' realizing process. We experience attitudes of gratitude and appreciation for the work of artisans and a sincere embracing of their creativity. From each drop of effort flows rich content developed via meticulous artistic transformations, all the while preserving heritage and culture. The stunning creations never cease to surprise us with their exciting cultural and creative momentum.

We invite you to join us to experience the beauty of contemporary fine crafts and to be touched by the immortal spirit of artisanal perseverance.

Director of the National Taiwan Craft Research and Development Institute

目錄／CONTENT

02　序
　　PREFACE

06　目錄
　　CONTENTS

09　展覽簡介
　　EXHIBITION INTRODUCTION

天工職人
MASTER ARTISANS

18　經典工藝
　　CLASSICAL CRAFTS

60　時尚工藝
　　FASHION CRAFTS

102　品牌工藝
　　BRAND CRAFTS

工藝大觀
FINE CRAFTS

126 窗彩明
MEMORIES FROM IRON

128 天下知
KNOWLEDGE WITH PRAGMATISM

130 敬天地
HEAVEN AND EARTH

134 一聲白
SOUNDS OF WHITENESS

136 倚竹修
SIMPLY JUST BAMBOO

138 心傳薪
BEQUEATH THE HEART

140 展覽空間
SPACE OF THE EXHIBITION

144 後記
POSTSCRIPT

150 臺北當代工藝設計分館介紹
NTCRI TAIPEI BRANCH INTRODUCTION

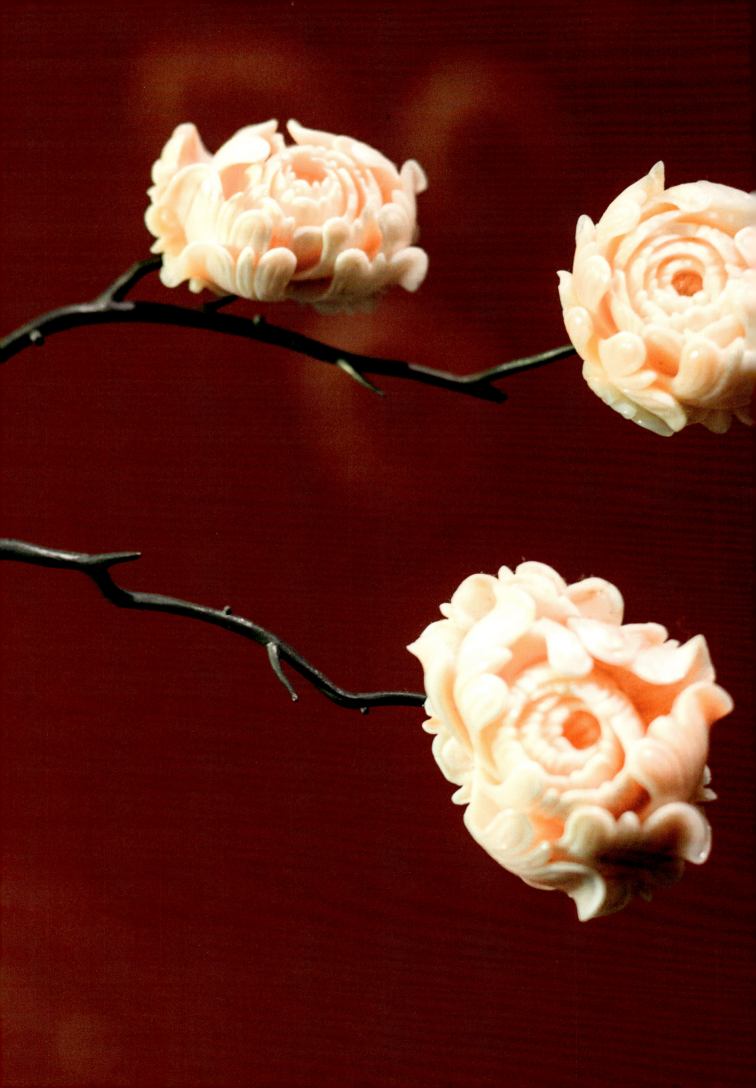

巧奪「天工」，藝匠再現
Masterpieces:
Revealing Excellence

1637 年明朝科學家宋應星編纂《天工開物》一書，開啟記錄工藝百科先河。書中詳盡蒐羅陶藝、丹青、珠玉、冶鑄、紡織等主題，更被法國漢學家儒蓮稱之為「技術百科全書」，使人一窺東方工藝的淵博與堂奧。工藝師曖曖內含光，需要慧眼伯樂展其長才，「國立臺灣工藝研究發展中心」(以下簡稱本中心) 正扮演著伯樂的角色，所屬「臺北當代工藝設計分館」的首展，特別以「天工」(Masterpieces: Contemporary Crafts Collection) 為名，呼應《天工開物》一書尊重多元、積極探索研究各類工藝的精神，提供舞臺展演工藝師們的傑作，並彰顯「工藝之美盡顯生活、職人精神傳承不朽」的價值，是對技術精湛的工藝師致敬，更喻意臺灣當代工藝師們精湛的技術「巧奪天工」！

仿天壇，核心所在地變身工藝的殿堂

「天壇」是明清兩代帝王孟春祈穀、夏至祈雨、冬至祈天的地方。國民政府播遷來臺後，為推動文化建設，選擇在南海路擘劃南海學園，由當時的教育部長張其昀規劃興建，這棟當年的最高建築物乃是 1956 年由建築師盧毓駿所設計，外觀設計仿北京天壇祈年殿的宮殿式重簷攢尖屋頂特色，突顯出天空的遼闊高遠，以表現「天」的至高無上。天壇內的「圜丘壇」是皇帝舉行祭天大禮的地方，天壇圜丘頂層正中央的圓形石板被稱為「太陽石」或「天心石」，回聲響亮，如同臺灣當代工藝師們嘔心瀝血創造屬於自己獨特價值的工藝作品，引動廣泛的迴響與震撼。

這幢寓意深遠的建築主體，還曾經是北臺灣孕育科學教育的館所，如今重新修整為「臺北當代工藝設計分館」，將昔日祭天祈福的所在地變身為工藝殿堂。翻開臺灣工藝發展脈絡史，正猶如本建物所呈顯的深遠意義—立足傳統、開創未來，扶植更多臺灣優秀的工藝師與國際論功夫、爭高下。本中心主任許耿修表示：「我們設計、生產臺灣當代最優質的工藝品，是未來世界各個博物館想要典藏的經典作品」，自我期許能打造一座「臺灣的當代故宮」，由此翻開臺灣工藝史上登峰造極的新扉頁。

展覽簡介 / EXHIBITION INTRODUCTION

人，師法自然

早期「工藝」的材料大多就地取材，這些源自庶民生活的設計跟材料，也影響了後續的工藝設計。公元前 3000 年到公元前 2000 年黑陶文化所使用的「陶土」和今日抗菌的陶瓷刀和精密陶瓷所選用的材料，兩者本質上並無二致，但是卻多了巧妙的創新與功能轉化。

工藝師向土地與自然謙卑的學習與探求，從文化和歷史累積涵養。隨時代遞嬗，這些當代工藝品的「作用」其實跟遠古一樣，杯子與碗的基本功能未變，卻更富含情感特質與美學語彙。策展人、自由落體總經理陳俊良說：「如何用取之於天地的材料，透過人工巧妙設計展現作品生命是工藝師們的天職，透過本展為職人撐起一片藍天，為工藝燃起一縷芳香。」

一座當代工藝的百工百貨

隨著時代潮流的演進，臺灣工藝發展也與時俱進，工藝不再是固守傳統的詞彙，相反的，擁有技術堅實養分基礎的工藝師們，早已將傳統的精華轉換為時尚的工藝語言，創造出來自土地、貼近生活的新時代作品，發展出屬於當代特質的風尚與價值，展現風華，躍上國際大舞臺。

為此，「臺北當代工藝設計分館」開館首展——「天工」，匯聚臺灣當代重要工藝職人們的精心傑作，建構出一座「當代工藝的百工百貨」，工藝家百家爭鳴的創作火花，透過百貨般的空間展現時尚工藝精品，讓民眾能愉悅地飽覽職人們精心創作的多元作品。

這場盛宴將顛覆一般人對工藝即傳統的窠臼與認知。各式突破傳統思維的工藝作品躍然眼前，也許是一只充滿設計感的單柄銀壺、一張時尚的鐵花窗椅、一件結合異媒材的衣裳……創新又精緻的工藝品項令人目不暇給。走逛「天工」大展，能產生猶如遊逛百貨公司的樂趣，展區處處充滿驚奇，時時看見新點子，拉近工藝與生活的距離，顛覆工藝即傳統的刻板印象，傳達工藝時尚化與生活化的美學體現。

展櫃構思，更以獨特的工藝思維來設計，將饒富雅趣的古典提籃，轉化為高 180 公分的展櫃造型，傳遞出古意的新形式，拉開兩方抽屜就變成物件的展臺，提把內暗藏投射燈，巧妙且具新意地照亮展品。另一類「多寶格」

式的展櫃設計，將古代帝王的玩具箱，轉換為展臺，線條簡潔俐落，成為烘托工藝作品的小舞臺。與展示架結合的燈座，選用線條立體的新「宮燈」造型，創新的陳列形式與燈光氛圍，洋溢古典雅趣。

工藝生活，彰顯職人精神

「天工」大展猶如一場工藝的文藝復興，蘊含族群的文化內涵、特質與精神。傳統的工藝手法如何融入當代生活？如何符合現代的需求？如何體現時代精神？為了成就完美的經典作品，時間淬煉與技術創新，工藝師扮演了舉足輕重的角色，這場展覽同時也是對職人精神的禮讚！職人精湛細膩的工藝技術，不妥協的態度與堅持，秉持著傾其一生投注於技藝的淬鍊和生命熱情。工藝與生活息息相關，庶民生活中蘊藏工藝之美，是人類生活智慧的結晶，伴隨刻鏤文明的步履，烙印美學的進程。

「職人（しょくにん）」專指傳承守護者代代相傳的傳統技藝，並透過雙手製造出良品的生產者；這群人熱情的從事創作，以擁有嚴謹、專業、用心、負責的態度感到自豪，這就是經過時間淬煉而形成的職人態度。職人們專注於創作的同時，生命也因此轉換，跨越時間和空間。職人精神，應該再次被召喚、重新被看見！透過「天工」大展，喚起老一輩再次感受手感時代的美好，也讓新世代的年輕人體驗在地的工藝精神與文化美學涵養。

生活美學是時代的顯學，浸潤在工藝世界中的職人們窮盡畢生的堅持與熱情，專注鑽研工藝，創造出兼具美感與實用價值的工藝作品。「天工」大展的展出只是一個起點，「臺北當代工藝設計分館」希冀透過這場跨世代、多元性工藝品的展出，能鼓動工藝宣揚的風潮，鼓勵更多優秀的工藝師推陳出新、勇於展現創新思維，創建以臺灣為核心發展的創意元素，在工藝技術上揮灑出獨特的燦爛光彩，真正打造一座名副其實的「臺灣的當代故宮」，推動臺灣的當代工藝作品邁向國際舞臺，真正體現巧奪天工的真諦！有朝一日，臺灣將可望被讚譽為具領導潮流地位的頂尖工藝大國。

展覽簡介 / EXHIBITION INTRODUCTION

The book, "The Exploitation of the Works of Nature", compiled by Ying-xing Song in 1637, during the Ming Dynasty, was the first Chinese encyclopedia that recorded illustrated details of the history of Chinese fine crafts including pottery, painting, jewelry, metalworking, textiles, and more. It was praised by the French Sinologist Stanislas Aignan Julien (1797-1873) as being at the leading edge of "technical encyclopedias", providing profound insights into the history of Oriental crafts. With its opening exhibition, "Masterpieces: Contemporary Crafts Collection", the Taipei Contemporary Craft Design Branch of the NTCRI (National Taiwan Craft Research and Development Institute) seeks to move fine crafts into the limelight where they belong. Its principles are tied closely to the book "The Exploitation of the Works of Nature" in advocating respecting diversity in fine crafts and proactively engaging in exploratory research. For the artisans, this exhibition provides an excellent venue to showcase their outstanding works. It is also a way to pay tribute to the artisans who have made the beauty of their fine crafts so tangible, while still continuing to highlight the spiritual heritage of their approach.

Traditional Core to Contemporary Stage

Throughout the Ming and Qing Dynasties, the Temple of Heaven in Beijing was a religious space for emperors to conduct prayer ceremonies during the spring for abundant harvests, throughout the summer for sufficient rains, and on the winter solstice to pay respects to the heavens. In order to sustain and promote cultural heritage and development after the Kuomintang government retreated to Taiwan in 1949, officials chose Nanhai Road in Taipei to initiate the construction of the Nanhai Academy, overseen by Education Minister Qi-Yun Zhang. In 1956, renowned architect Yu-Jun Lu designed the building, the tallest at the time, to be modeled on the Hall of Prayer for Good Harvests in Beijing's Temple of Heaven. The exterior, comprised of multiple layers of pointed palace-style roofs, suggests a vast skyline representing the supreme heavenly authority. On the central platform of the Circular Mound Altar, where an emperor would have performed ceremonies to pay respect to the heavens, sits a round stone named the "Sun Stone" or the "Heart of Heaven Stone". The resounding echoes of these ceremonies resonate with and reflect the unique values and outstanding fine crafts of artisans in Taiwan.

The core of this building began as the National Taiwan Science Education Center and has now been converted into the Taipei Contemporary Craft Design Branch of NTCRI, a conversion similar to the transformation from what was once a heavenly ceremonial podium to what is today a creative platform for fine crafts. The significant history of the development of Taiwan's

fine crafts synchronizes neatly with the history of this building; rooted in profound tradition yet heading towards a soaring future. Furthermore, this space supports and provides an excellent training ground within which artisans can refine their skills and prepare to contend internationally. "We will continue to take the lead in design trends to produce the best quality Taiwan contemporary fine crafts," says Director of NTCRI Keng-Hsiu Hsu.

"In the near future, these fine crafts will become part of precious collections in museums around the world." Going forward, this branch aims to become Taiwan's modern-day "National Palace Museum", creating a new chapter in the history of Taiwan's fine crafts.

Nature, the Teacher

Materials used for craft-making in earlier days were mostly found in the local surrounding area. Craft designs often took inspiration from day-to-day life, which would influence how crafts were designed and fashioned. For example, the "black clay" used between 3000 B.C. and 2000 B.C. in Black Pottery Culture (or Longshan Culture) is no different from the material used today for making antibacterial ceramic knives. Though the elements are in essence no different, the form and function of the new crafts have been skillfully transformed through clever innovation.

Artisans learn humility from nature and gather insight through exploring cultures and examining history. As time moves forward, while the functions of modern-day fine crafts such as cups and bowls may remain the same, their sentimental qualities can become imbued and permeated with a wider vocabulary of beauty. The Director of Freeimage Design, Jun-Liang Chen, has said, "It has become our responsibility as artisans to use materials that come from nature, and to bring these incredibly well-designed fine crafts to life. Through this exhibition we hope to expand this territory, allowing artisans to explore and to ignite a fresh essence as they bring fine crafts into our ordinary lives."

Contemporary Crafts Collection

Taiwan's fine crafts have established their own trends, changing with the flow of time, no longer fitting within a vocabulary of traditional definitions. They are cultivated using a foundational core and technological advancements that have slowly transformed the essence of conventional fine crafts, so that while they originate in nature, they also suit the modern-day lifestyle. They have developed their own unique qualities and values, ones that now also express elegance on the international stage.

展覽簡介／EXHIBITION INTRODUCTION

In recognition of this, the opening exhibition of the Taipei Contemporary Craft Design Branch, entitled "Masterpieces: Contemporary Crafts Collection", brings together distinguished artisans from all fields to present their exceptional fine crafts to the public. The exhibition also provides an environment for synergistic interactions to spark new ideas and kindle innovative spirits as we appreciate the fine crafts and creative skills of Taiwan's artisans.

This celebration offers a new perspective on the traditional concept and status of fine crafts. Diverse and creative imagery encourages viewers to let go of established viewpoints and to engage from new angles. Whether it is through the simple design of a single-handled silver pot, the design of a modern iron chair, or a piece of clothing made from various mediums, the exhibition's atmosphere is bound to draw you in and take your breath away. As you progress through the exhibits, your surroundings lead you to feel as if you are browsing through stylish boutiques, filled with delight and inspired with new ideas. The stereotypes attributed to traditional crafts gradually fade away as the connection between the idea of fine crafts and their place in everyday life is enhanced, with each piece bringing out the intrinsic value of aesthetics in Taiwan's contemporary fine crafts.

One of the unique features of the exhibition is the manner in which settings for the displays have been meticulously designed and planned out. We can see antique baskets converted into display shelves (as high as 180 cm) adding a primitive essence to a modern look, display spaces created by opening up antique cabinet drawers, and lighting cleverly hidden under carrying handles at an angle that ingeniously reflects the light. In another eye-catching display, the "Curio Cabinet" turns the Emperor's treasure chest into multiple separate boxes, creating unique individual displays. Designed to be concise, these multiple mini spaces fully highlight the prestige of the crafts. Additionally, lamp-stands that connect from the display shelves are carefully shaped in the form of palace lanterns, an innovative approach that creates a lighting atmosphere with a mix of classic elegance and ancient cleverness.

Live with Fine Crafts, Showcase the Artisanal Spirit

"Masterpieces" showcases a renaissance of fine crafts, containing the cultural connotations, characteristics and spirits of different ethnic groups — but it also brings us questions. How do we integrate traditional techniques into contemporary life? How do we meet the expectations and needs of modern-day society? How do we embody the spirit of the times? In order to achieve

the perfection of these classic works, long hours and effort spent innovating techniques were required. This exhibition pays tribute to the pivotal roles played by the artisans who have passionately devoted their lives to shaping their skills with an uncompromising attitude and a persistent strength. Their work reminds us that fine crafts and life are inextricably linked, and that core beauty is hidden within our daily experiences. Crafts are the manifestation of the wisdom of human life, and artisans shall continue to engage with civilization at every step and to engrave aesthetics in every process.

The term "craftsman" (しょくにん) refers specifically to those guardians of tradition who pass on classical skills from generation to generation. Using their hands to create, they pursue their chosen craft with passion, working always with rigorous attention to detail, professionalism, and pride. As they devote intense attention to their work, their life, beyond space and time, also begins to transform. Their natural spirits are renewed and shine through. For the older generation of experienced artisans this exhibition may rekindle those same joys of working with their hands. For a newer generation, it may provide them with fresh inspiration, as they witness the rich cultural heritage and aesthetic values that have been carried forward.

This "Masterpieces" exhibition is just the beginning. A more aesthetic way of living is becoming a reality. As artisans enthusiastically nourish their passion and persistently pursue creative and methodological improvements in creating fine crafts, they are producing new works with both aesthetic and pragmatic value. Going forward, with the NTCRI Taipei Contemporary Crafts Design Branch set on becoming Taiwan's modern-day "National Palace Museum", we hope that our cross generational and pluralistic approach will promote a new wave of innovation by giving artisans the courage to show innovative thinking and new approaches. We will promote and showcase Taiwan's remarkably talented artisans on the international stage and one day Taiwan will be acclaimed as a leading trendsetter in the fine crafts world.

天 工 職 人
MASTER ARTISANS

經典、時尚與品牌的舞臺
Master Artisans on Stage

此次「天工」大展共分區為「天工職人」主題展區與「工藝大觀」物意區兩大軸心，透過精選的方式挖掘出許多優秀的臺灣當代工藝師。「天工職人」主題展區以「人」為核心，介紹工藝職人的頂真精神與工藝作品；「工藝大觀」物意區則強調「物」的多元創作，鼓勵從生活為出發點，顛覆既有的物品意象，賦予新型定義與嶄新功能。透過展演不同面向的工藝作品，闡述「臺灣當代工藝美學與鑑賞」的精髓，讓美感元素與文化內涵能自然而然的融入日常生活中，也希望工藝師們經由本展相互激盪，交織出創作的絢爛火花！

「天工職人」主題區，以職人精神為核心，扶植文創發展為目的，分別邀請「經典工藝、時尚工藝、品牌工藝」等近 50 位橫跨產業與跨世代的職人參展。參與展出的工藝師們特別受邀為「天工」大展提出具有原創性與系列性的驚艷創作，展現臺灣豐沛的創意能量、激盪跨界交流契機。

The "Masterpieces" exhibition focuses on two themes: Master Artisans and Fine Crafts, and results from a careful selection process that discovered many extraordinary contemporary Taiwan artisans. In the "Master Artisans" area the focus is on showcasing remarkable works that expose the true artisanal spirit. In the "Fine Crafts" area the spotlight is on the many diverse and creative characteristics of the crafts. Viewers are encouraged to, using their lives as a starting point, break from established stereotypical viewpoints and in so doing give crafts new definitions and new features. Through this deeper appreciation of fine crafts it is possible to integrate natural beauty and cultural connections into our daily lives. We also hope the exhibition will provide the presenting artisans with a platform to interact with each other and to generate new creative sparks.

"Masterpieces" is centered on the sharing of the artisanal spirit and the fostering of cultural and creative development. Almost fifty skilled artisans from different generational backgrounds and fields of work have been invited to present. They have been divided into the three categories of classical, trendsetting, and those with their own brand and will showcase amazing original creations, including individual pieces and those produced as part of a series. Taken together the works demonstrate the abundant creative energy in Taiwan as well as the opportunity for future creative interaction.

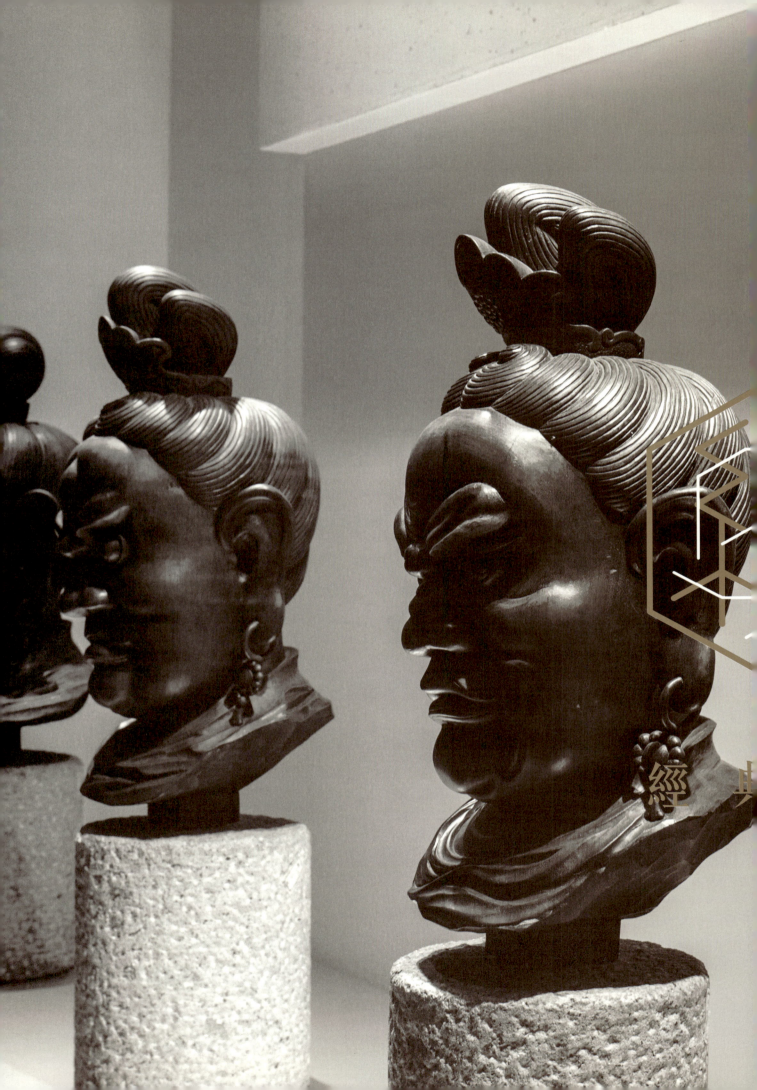

天工 當代工藝的百工百貨

找到經典，就不用害怕流行
Find the core at the heart of classic, one never fears facing the latest fashion

經典，永恆傳承歷久彌新。經典不等於傳統，所以找到經典，就不怕流行，經典作品永遠經得起時代的考驗，更要能夠推陳出新，無畏國際浪潮的挑戰。本展區以五行的「金、木、水、火、土」為分類，邀請十位資歷深厚、作品經過時代洗禮、具有代表性的經典工藝師，以顛覆自我及挑戰創作的態度，創作新藝。工藝師包含「金：金屬工藝師楊夕霞、銀帽工藝師林盟振」、「木：木雕工藝師李秉圭、竹編工藝師邱錦緞」、「水：天然染織工藝師陳景林、原民織藝師尤瑪‧達陸」、「火：雕釉陶藝師蘇世雄、實心雕塑工藝師黃安福」、「土：石雕工藝師馮朝宗、玉石工藝師吳義盛」等工藝經典名家。

The term "Classic" implies a timeless heritage signifying lasting quality. It doesn't just mean traditional, for once one finds the core at the heart of classic, one never fears facing the latest fashion. A true classic continually stands the test of time while incorporating new trends and challenges from home and abroad. This exhibition is based on the Chinese philosophy of the Five Elements: Metal, Wood, Water, Fire and Earth. Ten renowned artisans whose works have withstood the test of time, showcase classic pieces that daringly challenge tradition to create new art. The invited artisans are (Metal) Xi-Xia Yang and Meng-Zhen Lin, (Wood) Bing-Gui Li and Jin-Duan Qiu, (Water) Jing-Lin Chen and Youma Dalu, (Fire) Shi-Xiong Su and An-Fu Huang, and (Earth) Chao-Zong Feng and Yi-Sheng Wu.

金屬工藝師

楊夕霞

冰冷的金屬在楊夕霞的手中化為承載生命意義的媒材。她是臺灣擁有資深鍛敲技術的金屬工藝師，作品形式和內涵扣緊形體意象，善於從大自然中觀察與描摹，進而將感知經驗轉化為生命成形之初的振動，作品形色純粹卻充滿視覺張力。發揮金屬工藝材質擴張與收斂的特性，轉化為對自然生命的纖細關照，讓人深刻感受到一股柔軟的力量與伸展的姿態。

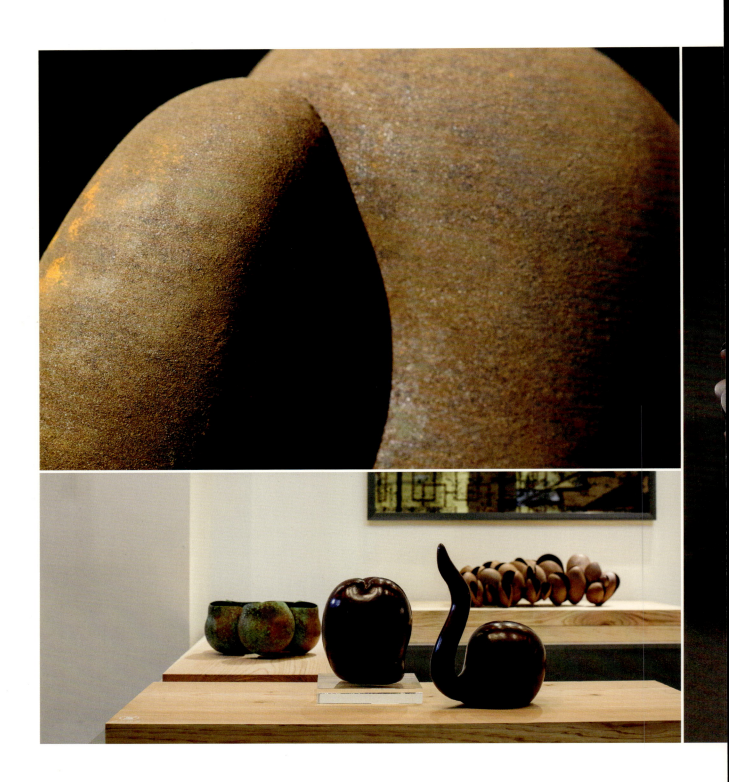

天工 當代工藝的百工百貨

銀帽工藝師

林盟振

神明銀帽工藝歷史悠遠,林盟振傳承府城「啟豐銀帽工藝社」的細銀民間藝術,致力於為神明粧添神冠,堅持純手工打造,細銀技術繁複而精緻,強調「柳絲、塹仔路、挑、刻」等打銀技法,抽出一條條比縫線還要細的銀絲,精緻的細銀技術令人讚嘆。他更結合現代工藝技術與西方設計元素,創新發想,提振傳統銀帽的藝術價值!

天工職人／MASTER ARTISANS

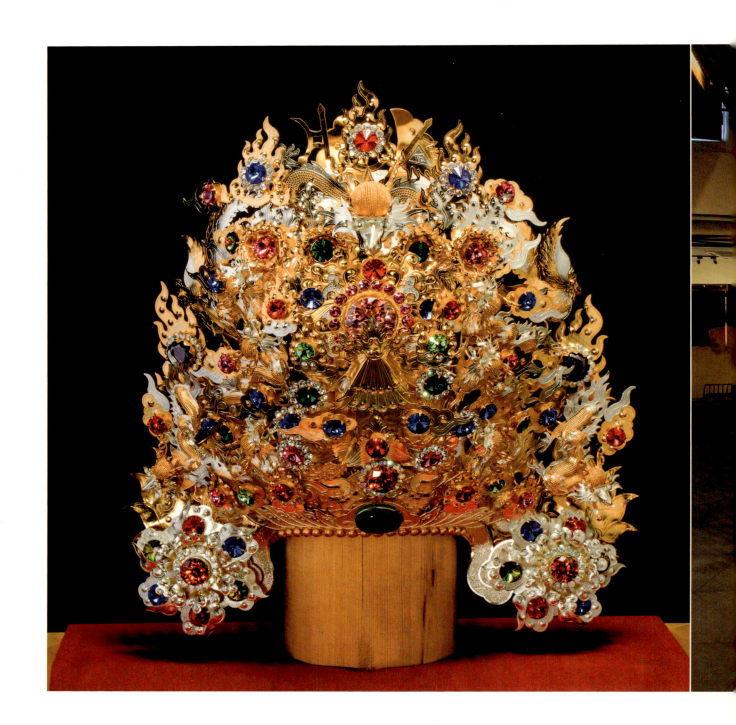

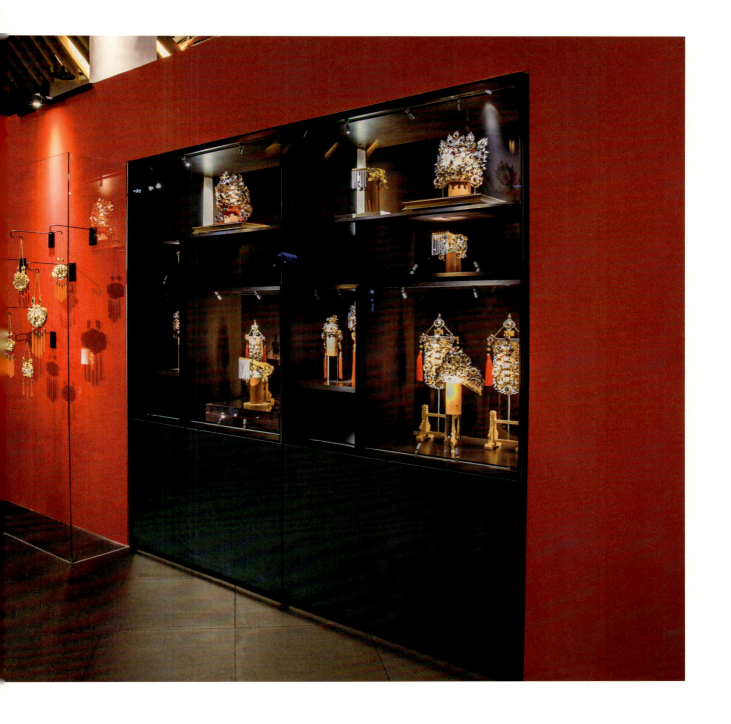

木雕工藝師

李秉圭

傳承家學的第五代木雕大師李秉圭，一刀一刻傳神地雕刻出神韻綽約的作品，他是文化資產保存技術「鑿花技術」的保存者，巧妙將傳統歷史建築或廟宇常見的木雕裝飾元素，應用在現代幾何造形上，講究材質紋理之美，用純粹紮實的刀法營造不同意境，並運用光影效果與裝飾技巧凝聚作品情境，彰顯木雕工藝價值，更展現工藝美學的新觀點。

天工職人／MASTER ARTISANS

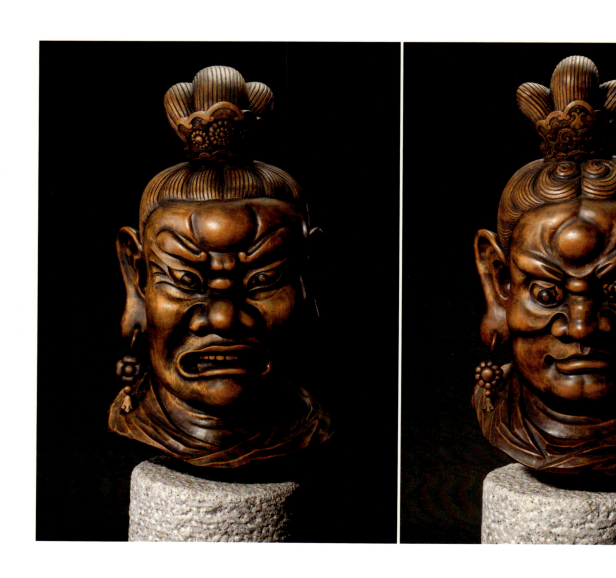

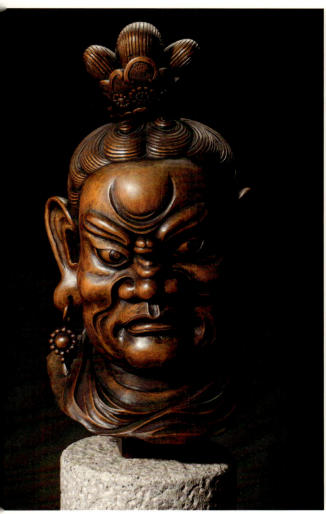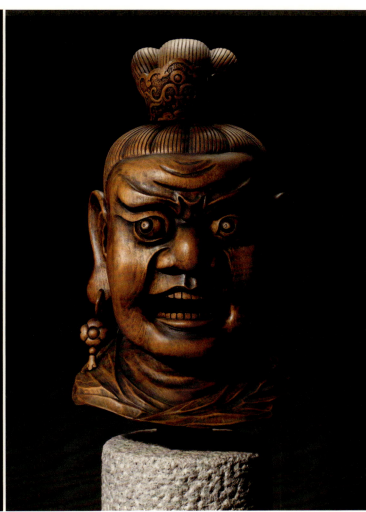

竹編工藝師
邱錦緞

運用竹材剛柔並濟的材質特性，邱錦緞以高超的竹編技藝，將數十隻竹篾操之在手，活用各式編織技法創作，縱橫交錯往來穿梭；既有理性序列的數學邏輯，同時兼具感性細膩的美感思維，創造出新潮又帶著復古情懷的竹編圖騰，紋理交疊美麗。其作品屢次奪得重要工藝競賽評審之青睞，邱錦緞除了創作悠然雅緻的竹藝品外，同時也積極推廣竹文化。

天工職人／MASTER ARTISANS

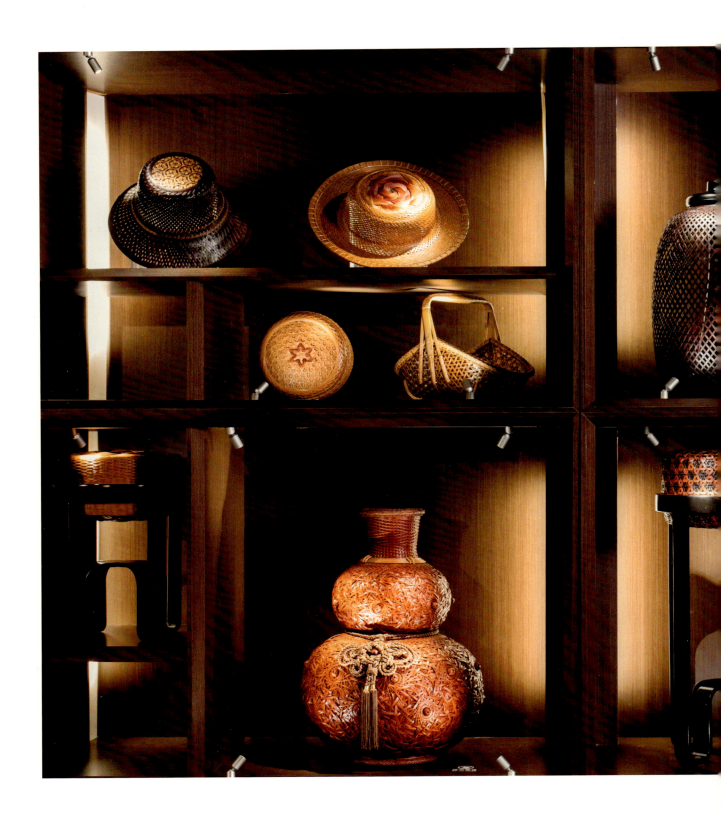

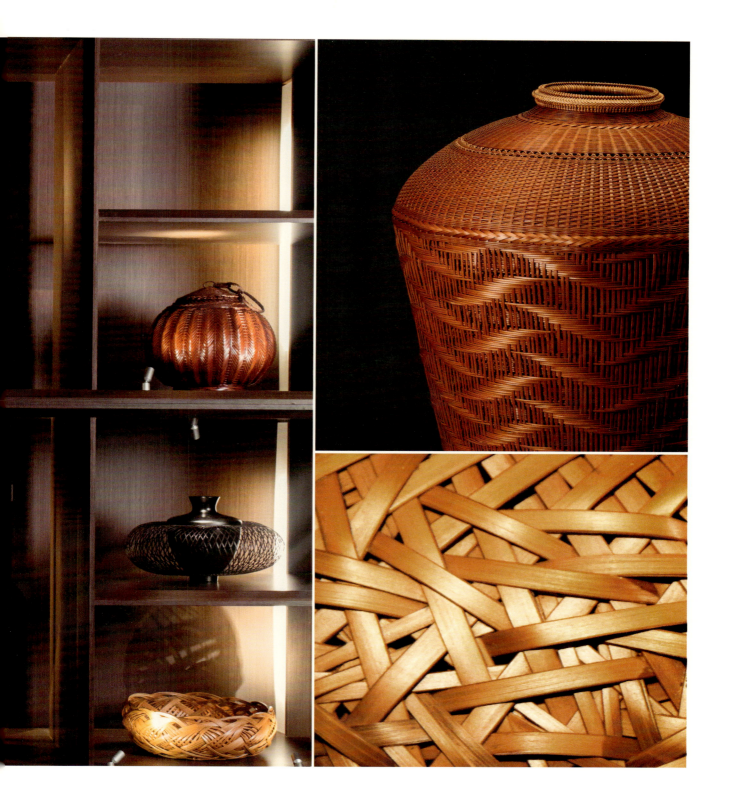

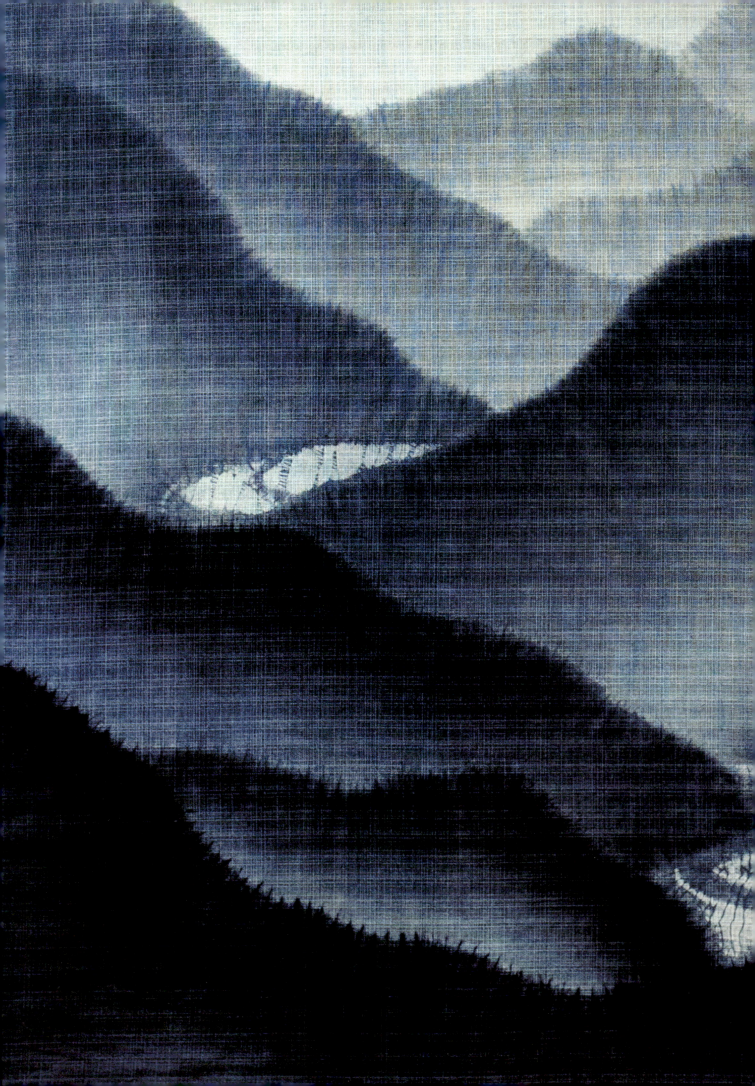

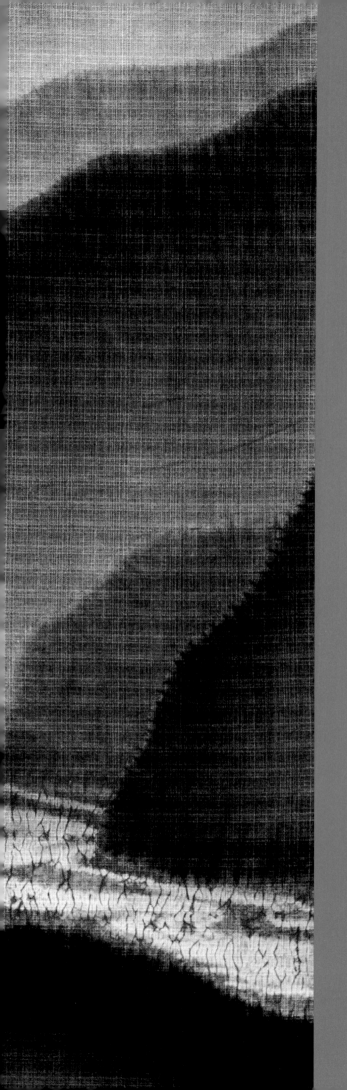

天然染織工藝師
陳景林

天地間的顏色都藏在陳景林的胸臆間，運用天然染色技藝，作品展現豐富層次，如潑墨山水，如霞霓雲彩，創作中不斷追尋屬於臺灣的色彩，研究超過 100 種染料，經過 2000 多次實驗，賦予染織技藝新風貌，運用色彩之美轉化為生命內在的表情，為傳統染織創造千萬價值。

天工職人／MASTER ARTISANS

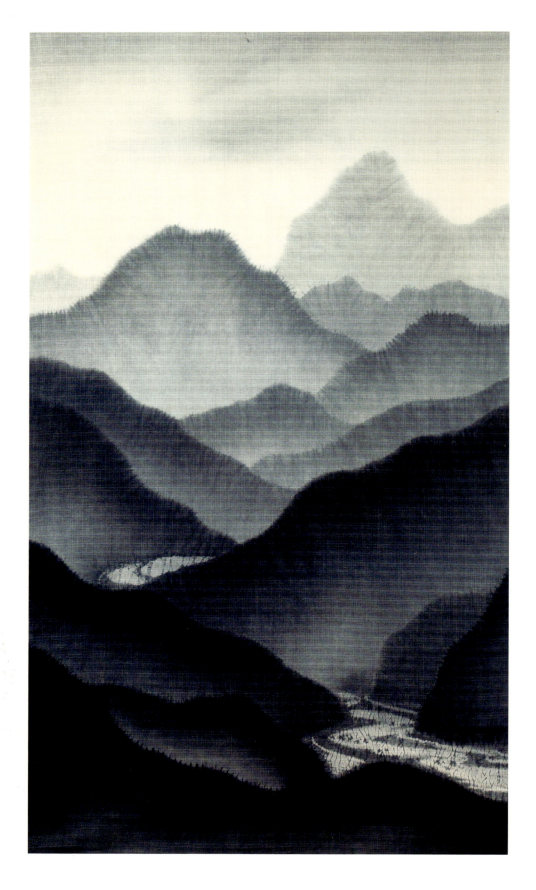

水里是八通關古道的起點，也是濁水溪和陳有蘭溪合流的交會點，水里以東山勢雄偉、水流湍急；水里以西，山巒漸低，水流漸緩。本作乃從永興村坪林望向龍神橋以東的濁水溪口，中央山脈氣勢磅礴，層巒疊翠，深具南投山鄉的景觀特色。本作以臺灣天然藍靛為染料，以獨創之山水層次紮染法染成，希望呈現臺灣山水之美。

本作為作者藍染山水的代表性作品，將水里山巒疊翠的景象呈現在染布上，傳統藍染雖為生活工藝品，卻也可以運用其技藝而從事藝術創作，也得以和山水繪畫並駕齊驅而成為較純粹的藝術品。

原民織藝師

尤瑪・達陸

致力於發揚臺灣泰雅編織技藝，尤瑪・達陸踏查了泛泰雅近百個部落以及國、內外有關泰雅典藏文物的研究分析，找尋失落的服飾織紋與背後的故事，重新建構部落文化認同，成功重現上百件泰雅族的傳統服裝，完成泰雅傳統織品服飾八大支系的整理、分類工作，期望復興泰雅文化。是少數能將傳統染織從材料的復育、種植、採收、製線、染色、織布等，完整呈現二十多道工序用心打造的織藝師。她更積極推動民族染織教育，期待能找回屬於泰雅族的自信與驕傲。

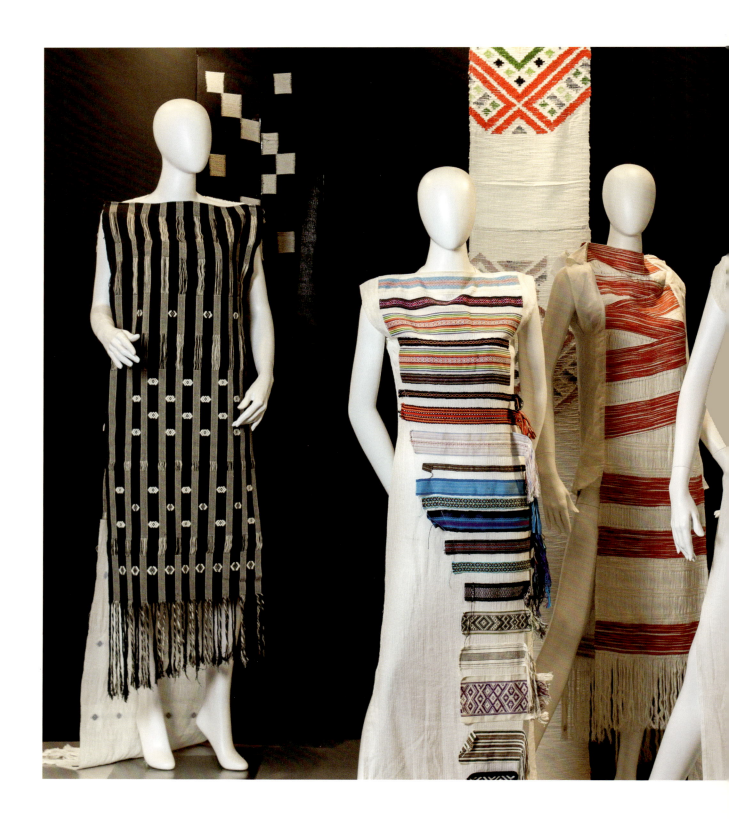

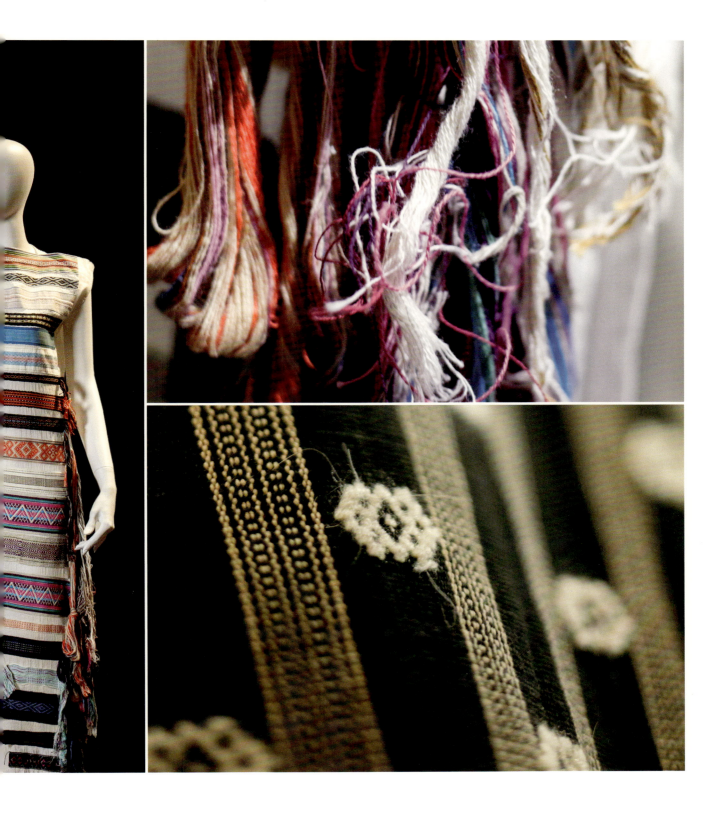

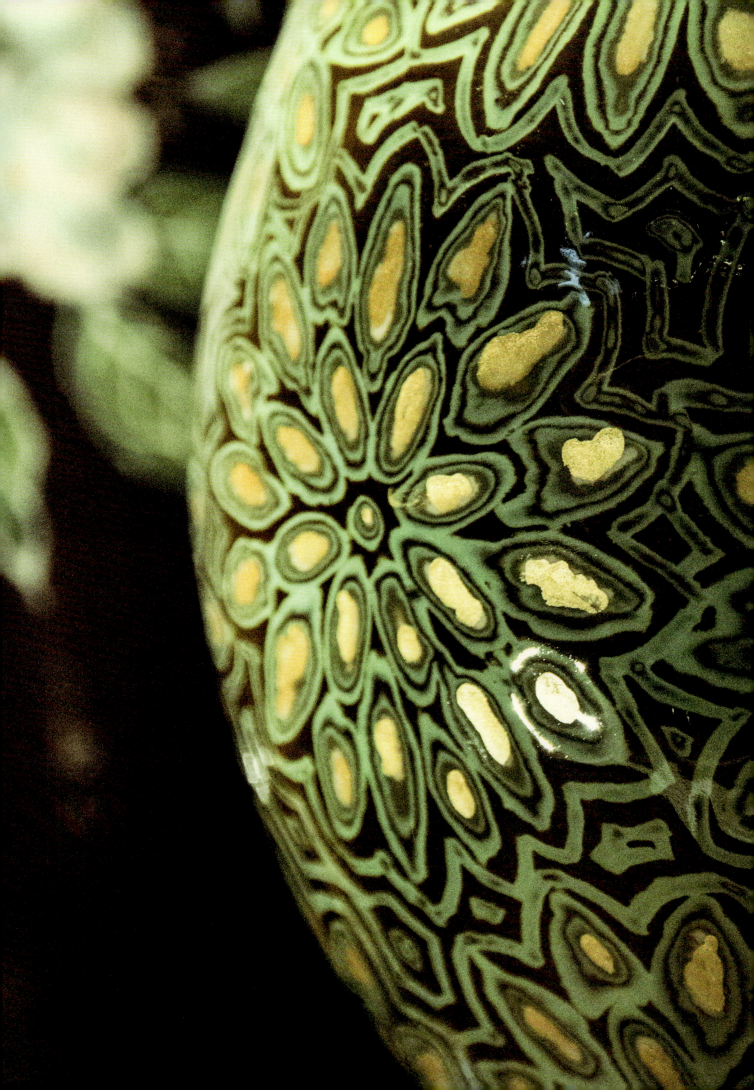

雕釉陶藝師

蘇世雄

蘇世雄在陶瓷技法上自創「雕釉」技法，經過拉坯、素燒、上釉、磨出色層、入窯、再上釉等繁複工序而成，結合傳統釉法和雕刻手法，工藝技術精湛。作品吐露「瑰麗典雅」的氣質，在傳統的陶藝器形上賦以現代感的視覺美感，取材於四季花卉，形制變化多元，成功結合「工藝」與「藝術」的雙重表現，作品變化多樣富於質感，賦予陶瓷藝術新的語言和生命。

天工職人／MASTER ARTISANS

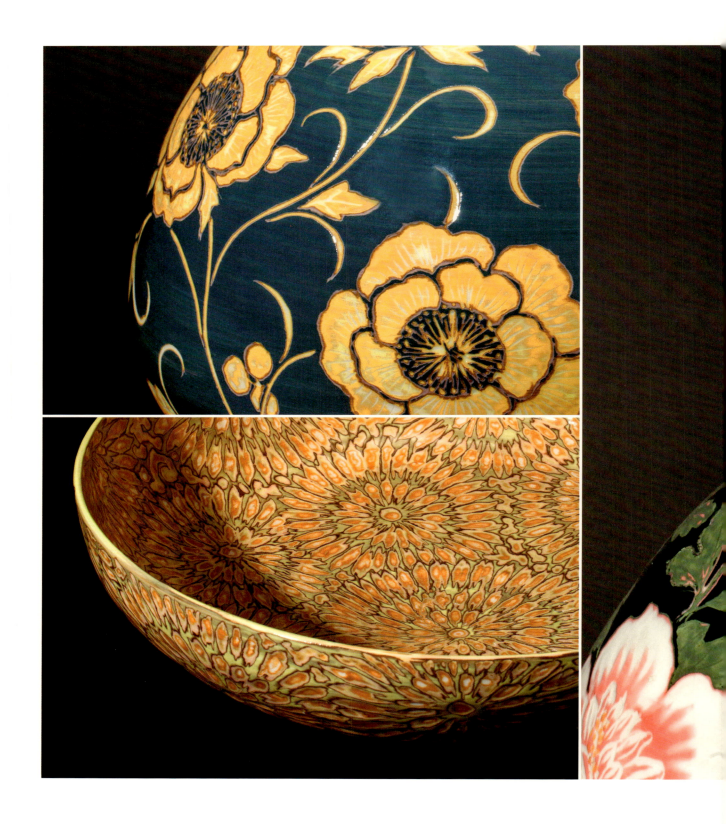

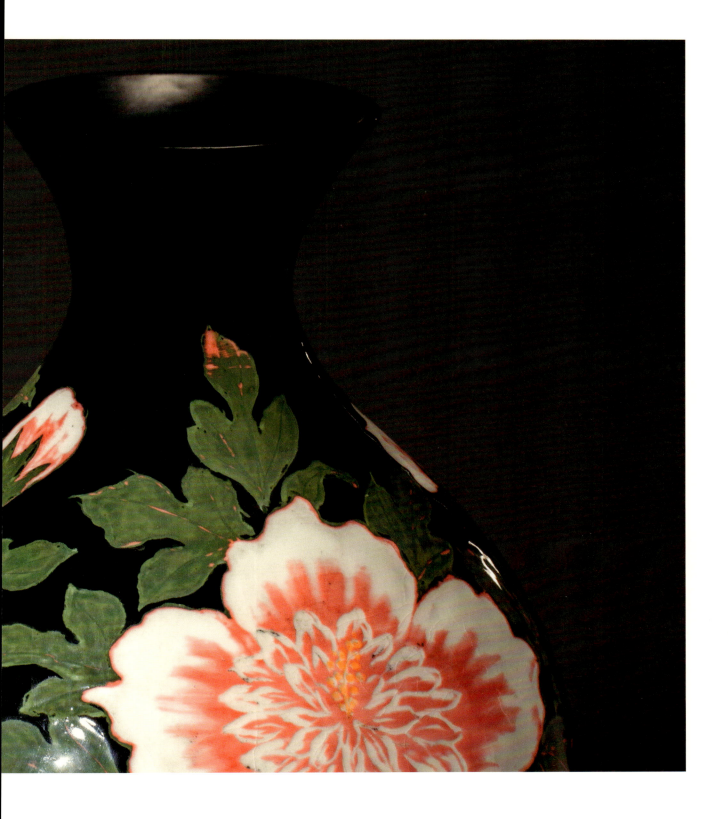

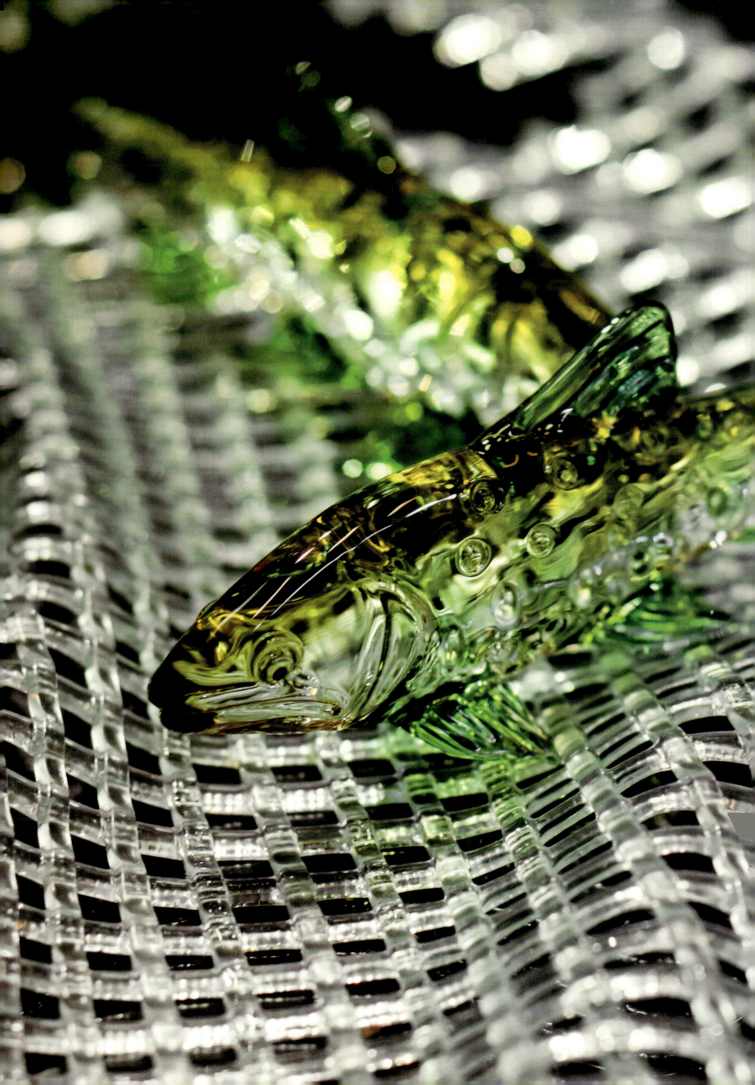

實心雕塑工藝師

黃安福

以「臺灣本土文化」為創作核心，黃安福的玻璃雕塑與生活主題相融合，不斷嘗試各種玻璃創意，創作技法成熟多元，如脫蠟、拉絲、實心雕塑等技法皆為其所擅長，運用玻璃材質的物理特性，千變萬化出各種不同的創意發想。強調敬虔虛心向自然學習的態度，主張藝術創作應依據所在的環境而有不同取向，細膩的雕塑蘊藏故事內涵，真摯執著的態度，讓作品與心靈意境相呼應。

天工職人／MASTER ARTISANS

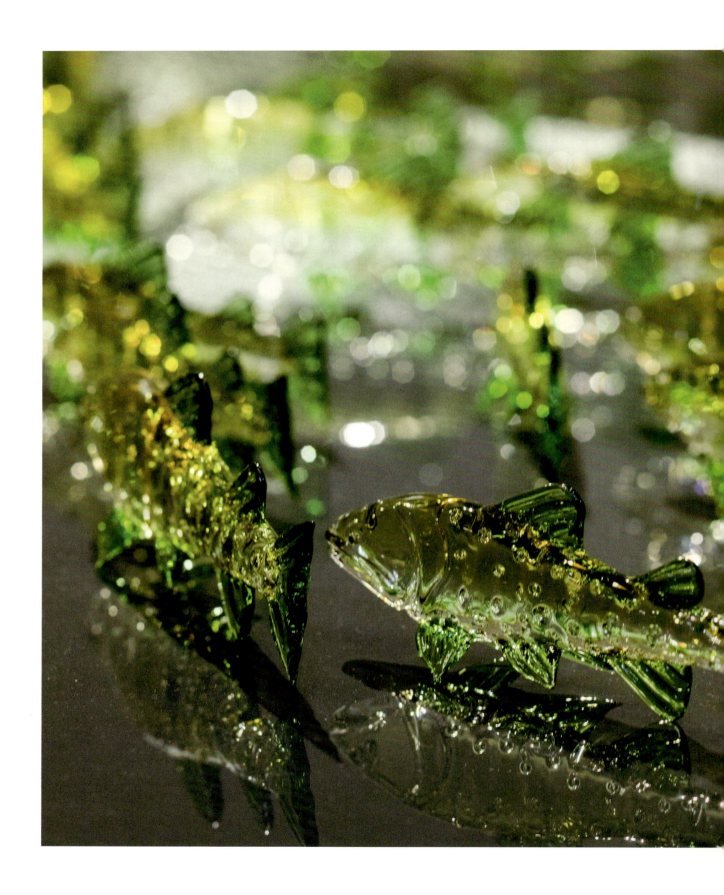

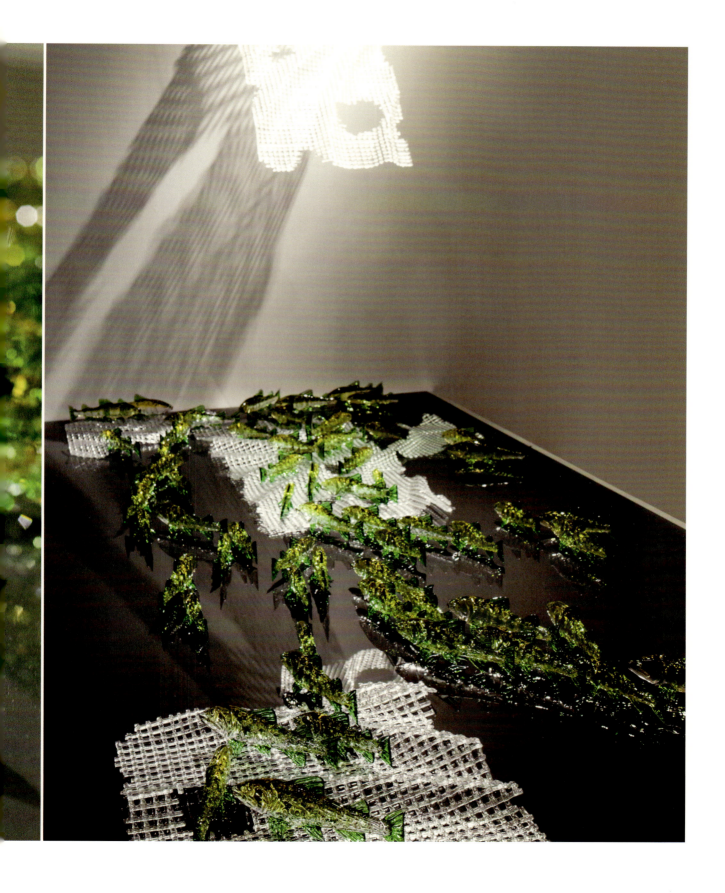

石雕工藝師

馮朝宗

線條簡約俐落，馮朝宗的石雕作品似柔實剛。原本堅硬的石材竟散發溫柔的旋律感，幻化成造型上的韻律起伏，讓人感受到物件透出的生命力，從「物」的領會，昇華至「心」的探索，作品衍生出更多元的豐富變化與內涵思維。

天工職人 ／ MASTER ARTISANS

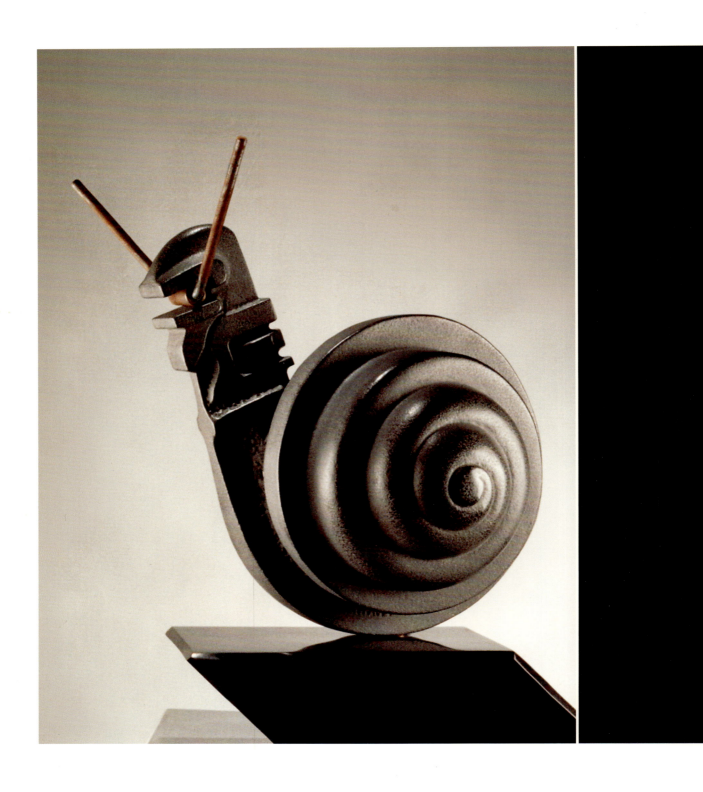

天工 當代工藝的百工百貨

玉石工藝師
吳義盛

長期鑽研玉石雕刻，吳義盛擁有傲人的雕刻技術，擅長仿古的繁複玉雕，近年來朝向生活應用面發展，藉由藝匠與設計的共生，創作造型簡約具現代時尚元素的墨玉作品，將花蓮墨玉瑰寶轉化與時俱進的創新元素，忠實呈現玉石質地，傳達愛物惜物的心，也彰顯臺灣金相玉質的精神與價值。

天工職人／MASTER ARTISANS

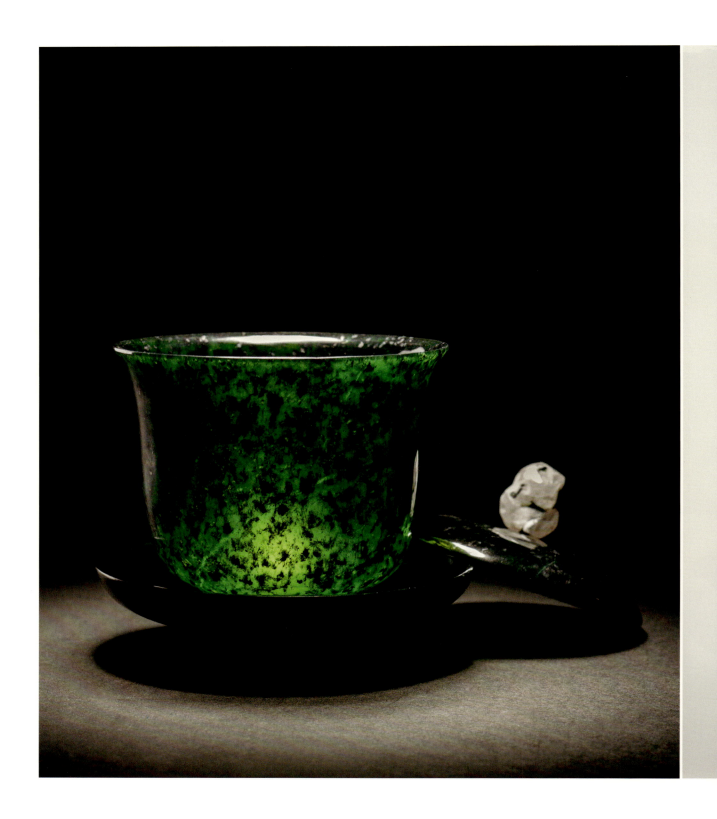

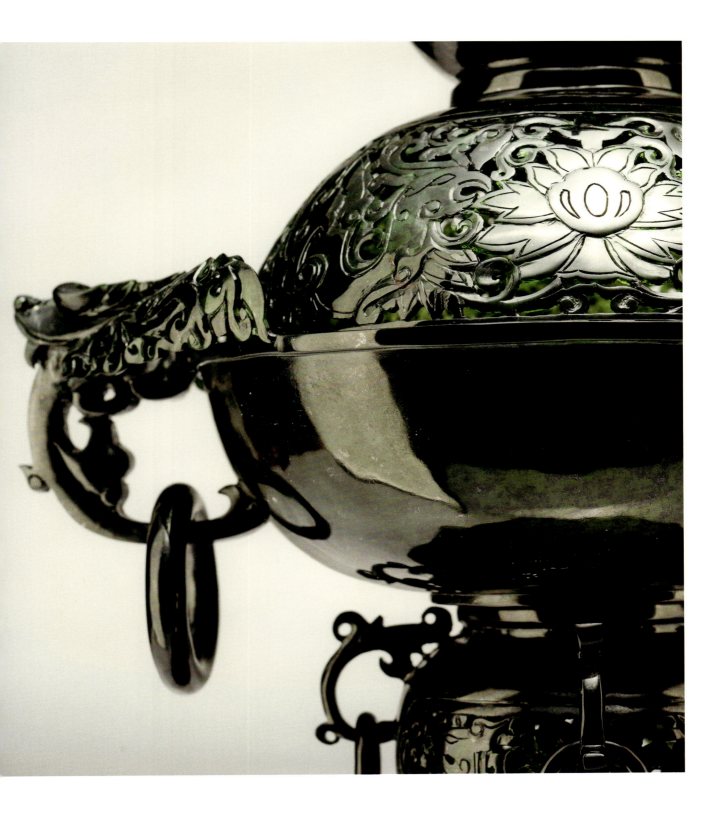

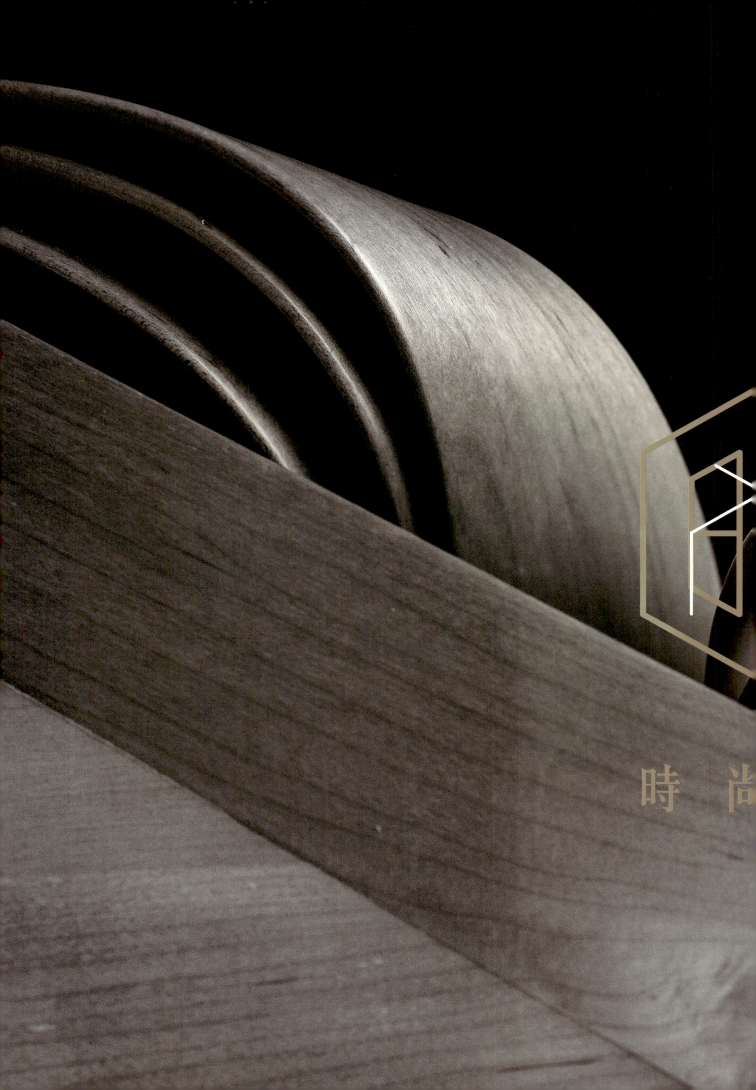

天工 當代工藝的百工百貨

創造時尚，成就工藝新世代
Trendsetters,
a New Generation of Creative Achievers

時尚，拍動美麗時代新浪潮。近年來臺灣工藝界新秀輩出，展現令人一新耳目的創作。扶植工藝師、帶動產業發展是「臺北當代工藝設計分館」的重要使命與任務之一。年輕的工藝創作者在師法經典工藝前輩傑出的表現之際，更積極展現絕佳創意，作品在國際舞臺屢創耀眼佳績，為臺灣發聲。

此次受邀的時尚工藝師不乏已是國際知名新秀，有些則在畢業專題製作嶄露頭角，包括：專攻金工飾品的謝旻玲、陳郁君、趙永惠、吳竟銍；以織品服飾取勝的陳劭彥、黃嚴慶、鄭鈺錡、陳敬凱；改寫器物工藝定義的吳孝儒、王帥權、吳偉丞、廖勝文；創新傢俱設計的黃俊傑、呂岳軒、周育潤、魏忠科等令人矚目、展翅翱翔中的新銳時尚工藝師。他們將是下一波引領臺灣工藝時尚產業發展的新動力，展現多元美感價值，重新定義工藝流行。

In recent years a new generation in contemporary fine crafts has infused fresh energy into the field, creating new trends and styles, like ocean waves heading towards the shore at high tide. Influenced and surrounded by experienced artisans, this young creative generation has learned eagerly and taken up the opportunity to showcase their dazzling creative skills. Their outstanding results have brought attention to Taiwan and earned them international recognition. Recognizing this, the NTCRI Taipei Branch is making it a primary objective to show strong support for young artisans to help lead the development of the Fine Crafts industry.
There is no shortage of internationally renowned artisans in this exhibition but we also welcome a number of remarkable up and coming artisans who have produced outstanding graduation projects. In the area of metalworking they are Min-Ling Xie, Yu-Jun Chen, Yong-Hui Zhao and Jing-Zhi Wu. Within textiles we have Shao-Yan Chen, Yan-Qing Huang, Yu-Qi Zheng and Jing-Kai Chen. Under transformative design are Xiao-Ru Wu, Shuai-Quan Wang, Wei-Cheng Wu and Sheng-Wen Liao. And, in innovative furniture design, Chun-Chieh Huang, Yue-Xuan Lu, Yu-Ren Zhou, and Zhong-Ke Wei provide us with cutting edge works. These up and coming artisans are going to be at the forefront of the next wave as it powers and redefines the Taiwan modern fine crafts movement.

金工飾品工藝
Metalworking design

專攻金工飾品的謝旻玲與陳郁君皆赴歐洲留學,深刻體驗美是自然而然從生活中發生的事,在 2010 年創立了 MANO 慢鏝金工工作室,期許大眾能用心去感受手作的美好與價值。趙永惠以建築表面的鐵窗和鐵皮等附著物為創意發想,表達首飾附著於人體的裝飾性,透過媒材融合與技術的轉換,解構人與物之間的關聯性。吳竟銍採用空窗琺瑯表現技法,將臺灣「雨水的痕跡」表現得輕盈通透。

謝旻玲
Min-Ling, Xie

陳郁君
Yu-Jun, Chen

趙永惠
Yong-Hui, Zhao

吳竟銍
Jing-Zhi, Wu

金工飾品工藝

謝旻玲

主修雕塑,在德國修習傳統及當代首飾,嚴謹環境下深植於心的是對專業的堅持態度。深刻體驗美是自然而然從生活中發生的事,在2010年成立「MANO慢鏝金工」,「MANO」在義大利文裡是「手」的意思,鏝則選自《爾雅・釋宮》,是建築師傅塗抹牆壁的工具。期許大眾能用心感受手作的美好與價值。謝旻玲不斷尋找東西方間的平衡點,特別衷情於創作具有透薄質感的金工設計,引動人們思考物與人的感受連結。

靜物 Still objects
紅銅 Copper
12.8 (L) x 12.8 (W) x 58 (H) cm

天工職人／MASTER ARTISANS

金工飾品工藝

陳郁君

經歷義大利、荷蘭金屬工藝教育的陶冶，留學歐洲的生活歷練與對文化的細微觀察，陳郁君融合歐洲金工技術與美學觀，在 2010 年和謝旻玲、王廣文一起創立「MANO 慢鏝金工」，跳脫傳統金工思維的首飾創作，融會東西文化的理性與感性、內斂與外放、律動與沈靜，依材質樣貌的「形」傳遞「無形」的情感，顛覆首飾既有的刻板印象。

疊 Stack
鐵、漆、木、銀、珊瑚 Iron, lacquer, wood, silver, coral
φ15cm

載 Carry
銀、珊瑚 silver, coral
10(L) x 8(W) x 1.5(H) cm

天工職人／MASTER ARTISANS

金工飾品工藝

趙永惠

趙永惠以建築表面的鐵窗和鐵皮等附著物為創意發想,剛硬的金屬材質成為時尚的穿戴首飾,企圖傳達首飾裝飾附著於人體後也改變了載體的樣態,透過媒材融合,解構人與物之間的關聯性,鐵窗飾品也成為居住者或配戴者日積月累的生活痕跡,似乎也產生某種心中的歸屬感。

鐵窗二 Iron window II
白銅 *Copper nickel*
8 (L) x 8 (W) x 2 (H) cm

天工職人／MASTER ARTISANS

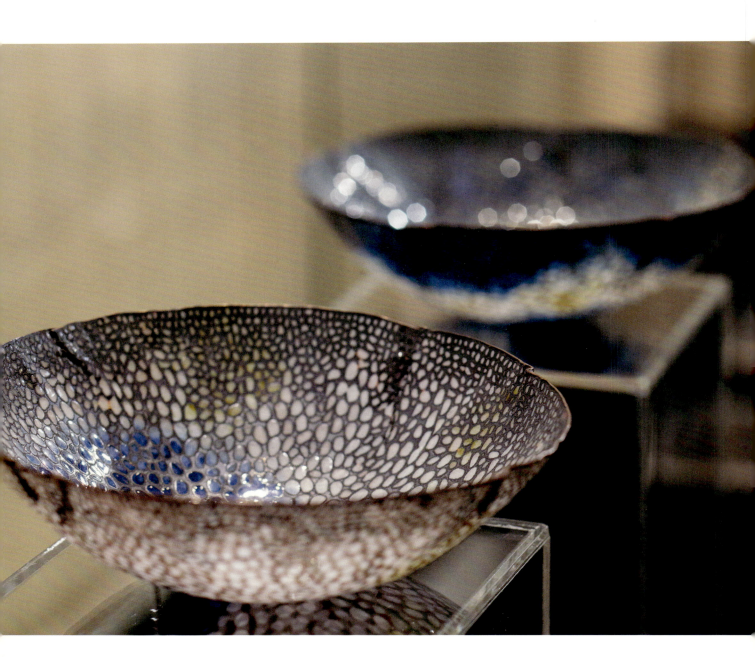

金工飾品工藝

吳竟銍

藉由金工傳遞內心對美感的追求及藝術理想，吳竟銍擅長採用繁複且細緻的鍛敲與空窗琺瑯技法，將金屬材質以精細的手法結合為優雅詩意的造型，設計出兼具美感與功能性的工藝品，作品「雨水的痕跡」表現雨水灑落的輕盈通透感，詮釋生活和情感的紀錄。

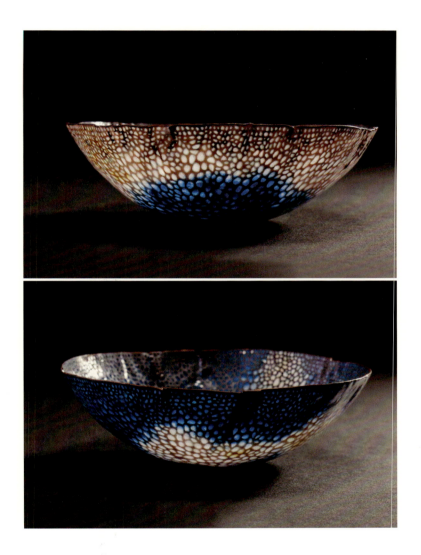

雨水的痕跡 Traces of rain
銅、琺瑯 *copper, enamel*
12(L) x 12(W) x 8(H) cm

織品服飾工藝
Textiles design

來自宜蘭的時尚工藝師陳劭彥以「SHAO YEN」為品牌連續十季在倫敦時裝周發表作品，2015 年以苗栗藺草為服裝材質，顛覆產業用新材料看時尚工藝，也讓全世界看到臺灣的工藝實力。黃嚴慶在「寶島新樂園」主題的實驗性服裝作品中，藉由珠簾與軍服細節呈現寶島眷村文化氛圍，在追求創新的同時，不忘傳承與文化。鄭鈺錡為新銳服裝設計師，作品「千牛」在實踐大學創意組畢業展演展露頭角，設計思維呈現高度的創造力及感染力，驚艷全場成為眾所矚目的焦點。陳敬凱所創立經營的「ChenJingkai Office」工作室，專門客製化訂做簡約造型鞋款，堅持從頭做起才能關注到細節，從平凡中做出不平凡的優良品質。

陳劭彥
Shao-Yen, Chen

黃嚴慶
Yan-Qing, Huang

鄭鈺錡
Yu-Qi, Zheng

陳敬凱
Jing-Kai, Chen

天工職人／MASTER ARTISANS

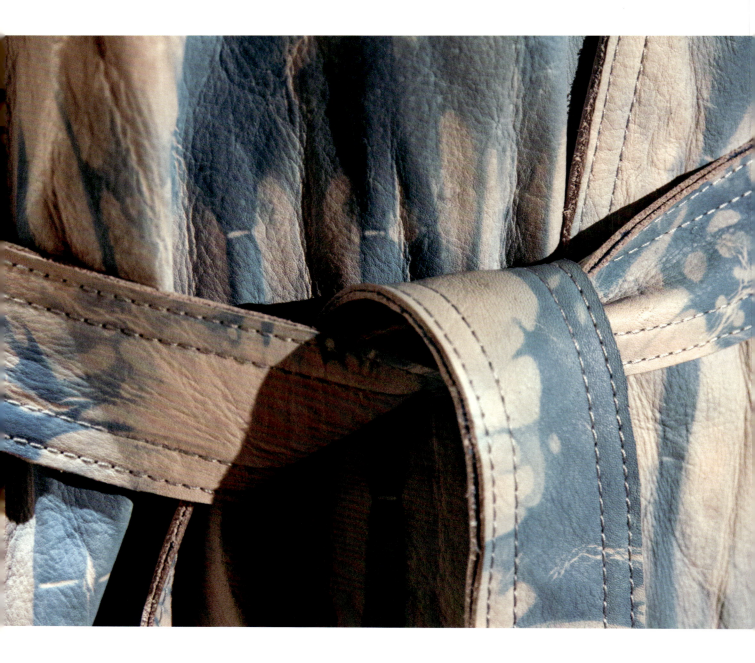

織品服飾工藝

陳劭彥

來自宜蘭的旅英時尚工藝師陳劭彥,主修針織,擅長開發、研究布料,以「SHAO YEN」為品牌連續十季在倫敦時裝週發表作品,2015年以苗栗藺草為服裝材質,巧妙運用臺灣本土素材創作,鑽研各種織染紋理的處理與實驗顏色拼接,嘗試混搭特殊的材質應用,顛覆產業用新材料揮灑時尚工藝,也讓全世界看到臺灣的工藝實力。

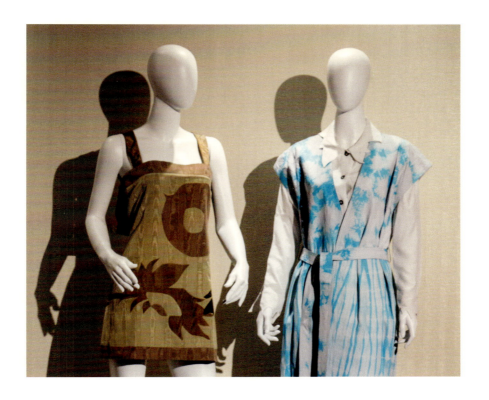

CANVAS
牛皮、布、手工紮染技法
cowhide, fabric, tie dye technique

天工職人／MASTER ARTISANS

織品服飾工藝

黃嚴慶

實踐大學服裝設計系畢業,「寶島新樂園」主題的實驗性服裝作品中,藉由珠簾與軍服細節呈現寶島眷村文化氛圍,色彩明亮,質感輕盈,黃嚴慶將零散的元素重新拼貼組合,在追求創新的同時,不忘傳承與文化。

天工 當代工藝的百工百貨

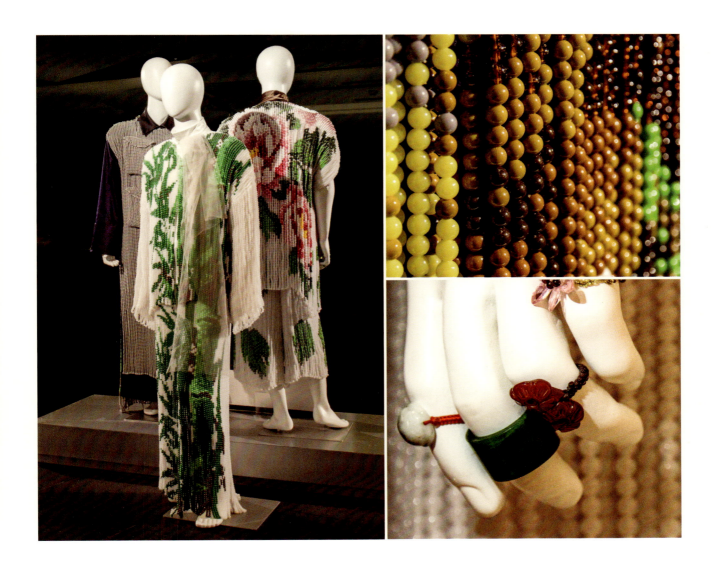

寶島新樂園 New paradise in Formosa
珠簾
beaded curtain

天工職人／MASTER ARTISANS

織品服飾工藝

鄭鈺錡

實踐大學服裝設計系畢業，鄭鈺錡為新銳服裝設計師，以「千牛」命名的實驗性服裝，在畢業展演展露頭角。作品注重美感與細節設計，善於異材質布料拼貼組合，嘗試各種立體版型與服裝輪廓型，企圖創造新的服裝視覺藝術，透過工藝技法將媒材處理成為可製作服裝的材料，呈現高度的創造力及感染力。

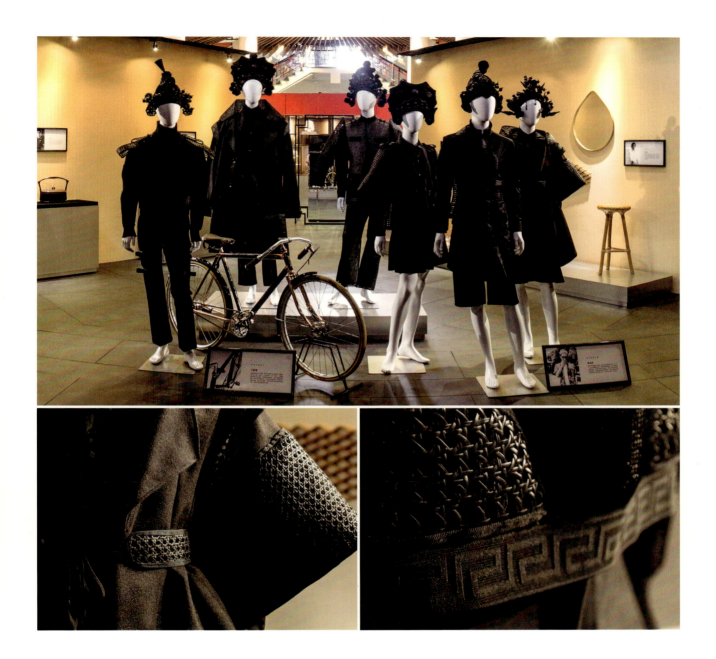

千牛 Qian Niu
布料、藤編、異材質
fabric, rattan weaving, different materials

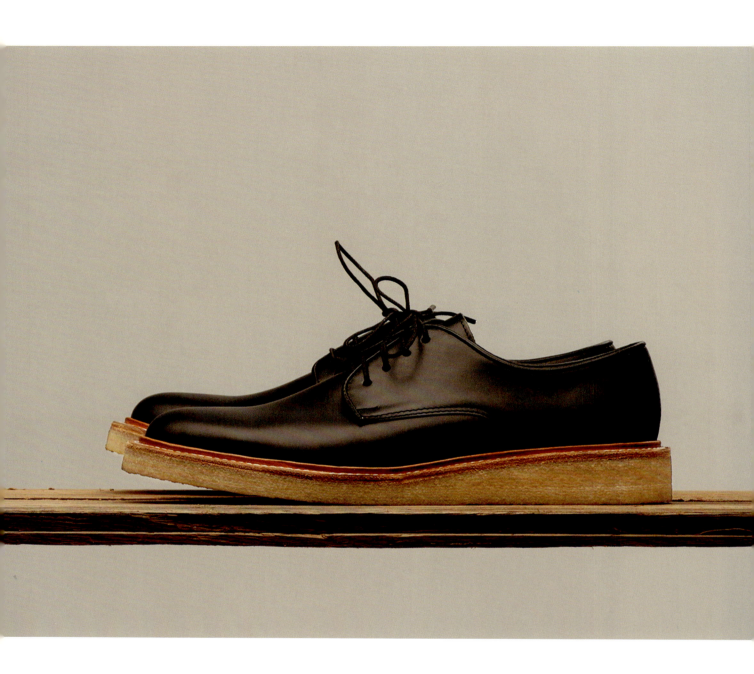

織品服飾工藝

陳敬凱

陳敬凱家承臺灣三十年的造鞋技術，在2006年創立經營的「ChenJingKai Office」工作室，專門客製化訂做簡約造型鞋款，堅持從頭做起才能關注到細節，從平凡中做出不平凡的優良品質。他有感於皮鞋製作技藝逐漸式微與沒落，發揮平面設計美學的專業，費時三年研發出黃金比例的皮鞋，堅持細節的優良品質，打造臺灣訂製皮鞋時尚新潮流，致力發展「Made in Taiwan」的精神。

皮鞋 Leather Shoes
皮革
leather

器物工藝設計

Under transformative design

專精器物工藝創作的設計師吳孝儒，善於將東方元素融會於西方思維，結合臺灣工藝與俗民文化，他的作品能感受到最直接的生活態度與常民智慧。王帥權作品「黑燕」，將腳踏車的車架以老件翻新，唐草為圖案基底裝飾，用吉祥燕子圖案搭配，營造出具有東方韻味的經典質感。吳偉丞關注與創造生活之美，陶藝作品表面的紋路與肌理色彩紀錄著創作的過程，期許留下對形體的真實感受和軌跡。廖勝文以脫胎漆器與變塗技法見長，崇尚自然，將傳統工藝質樸的特質加入現代元素，作品饒富自然氣息。

吳孝儒
Xiao-Ru,
Wu

王帥權
Shuai-Quan,
Wang

吳偉丞
Wei-Cheng,
Wu

廖勝文
Sheng-Wen,
Liao

天工職人／MASTER ARTISANS

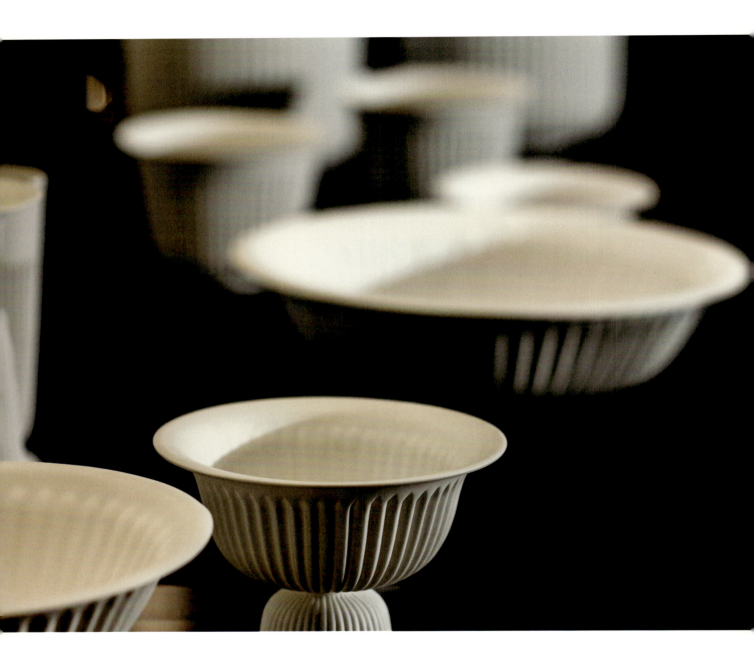

器物工藝設計

吳孝儒

吳孝儒的個人設計工作室 PiliWu-Design（吳氏設計），以發揚臺灣在東方設計的發言權為創立目標，追求所見、所看、所感受都能連結最真切的臺灣生活面貌，他透過街角文化、庶民文化去挖掘靈感，以當代美學為基礎，設計出看似衝突的民俗與工藝作品。從他的作品可以感受到最直接的生活態度與常民智慧。

Tse 瓷器
素瓷 eggshell porcelain
Height 7~19cm, φ 9.5~19cm

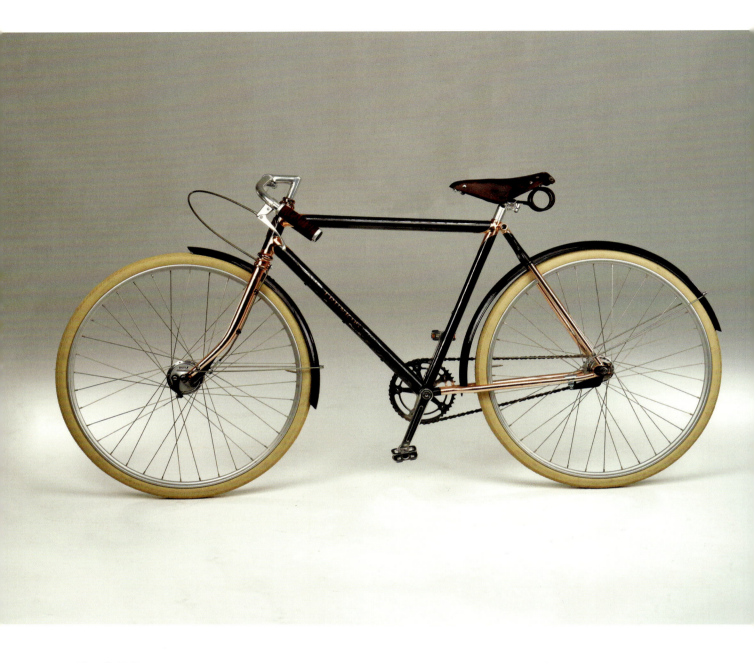

器物工藝設計

王帥權

創客塗裝創辦人王帥權，專注於各種媒介的塗裝技術，鑽研各種材質、塗料、合成、手工塗裝研究，作品「黑燕」，將腳踏車的車架以老件翻新，呼應健康環保趨勢，以唐草為圖案基底裝飾，用吉祥燕子圖案搭配，運用噴塗堆疊技術，產生猶如琺瑯般的效果，營造出經典質感，創造出塗裝彩繪世界裡的無限可能，呈現東方韻味展現經典工藝。

黑燕 Black swallow
漆
lacquer

天工職人／MASTER ARTISANS

器物工藝設計

吳偉丞

吳偉丞關注與創造生活之美，強調陶藝作品表面的紋路與肌理色彩，他以現代建築形式為概念，轉換陶器細節特色，簡化、誇張、加工、重組，透過泥土重塑過程，創造一種新的美感形式，作品本身就紀錄了創作的過程，留下對形體的真實感受和軌跡，也為生活帶來新的感動。

破常相 Breaking conventions
陶、瓷、鐵件
pottery, porcelain, Iron

天工職人／MASTER ARTISANS

器物工藝設計

廖勝文

在漆藝創作上著重天然漆料的運用，廖勝文以脫胎漆器與變塗技法見長，採用紅、黑、金三種顏色，嘗試結合新的材料與各種現代材質，尋找突破創新的可行性，將即將失傳的漆藝導入生活，作品散發工藝簡單樸實的氣息、崇尚自然精神，古典又不失現代。

春,夏,秋,冬 Four seasons
生漆、棉布、蛋殼、銀箔 raw lacquer, cotton fabric, egg shell, silver leaf
13(L) x 13(W) x 31(H) cm

創新傢俱工藝
Innovative furniture design

創新傢俱設計師周育潤，擅長以文化優勢突顯創作，注重永續與環保觀念，運用竹材取代木頭製作傢俱。設計「緣訂雙方」與「和合天成」的國立屏東科技大學木材科學與設計系的黃俊傑老師，調教出呂岳軒這位新銳設計師，創作出動感的「誘惑」傢俱，打破傢俱的線性思維；魏忠科為木語漆品牌創辦人，主要從事細木作、漆器作品開發傢飾設計，作品鍾愛原木作的溫潤表現紋理，以實用及美感為創作的主軸核心，藉此表述對材料惜物戀物的珍惜。

黃俊傑
Chun-Chieh, Huang

呂岳軒
Yue-Xuan, Lu

周育潤
Yu-Ren, Zhou

魏忠科
Zhong-Ke, Wei

天工職人／MASTER ARTISANS

創新傢俱工藝

黃俊傑

黃俊傑成立「正合木創」，專注於現代東方風格與現代設計的竹木生活工藝，作品兼具傳統、傳承與創新元素，進而提升臺灣傢俱精緻化與高價值。其所設計的各式家用品，如燭臺、茶盤、茶罐、杯墊、兒童玩具、文具以及各種器皿等等，皆結合臺灣文化圖騰，讓創意竹木製品更具有濃厚的「臺灣味」。

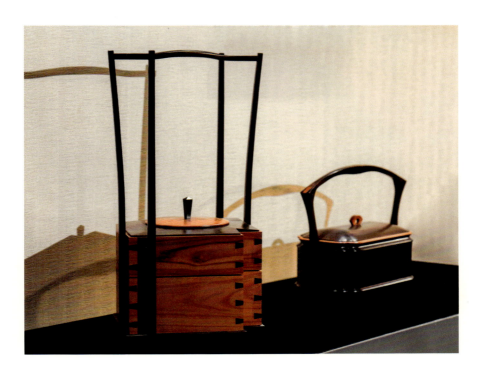

和合天成　Match made in heaven
金剛紫檀、菲律賓紅木　*rosewood, pterocarpus echinatus pers.*
29 (L) x 38(W) x 28 (H) cm

緣訂雙方　Betrothedur
金剛紫檀、菲律賓紅木　*rosewood, pterocarpus echinatus pers.*
56 (L) x 40(W) x 36 (H) cm

天工職人 / MASTER ARTISANS

創新傢俱工藝

周育潤

產品設計師周育潤是現任 KEV Design 的負責人，擅長以文化優勢突顯創作，他認為設計就像是在探索如何與物品互動的過程，從不同面向思考問題的癥結，進而改造、創造更多可能性。將竹編工藝結合傳統工藝與當代設計思維，注重永續與環保觀念，運用天然竹材製造傢俱，使每一件作品都展現出獨一無二的精神。

noodle
孟宗竹 *moso bamboo*
120(L) x 50(W) x 3(H) cm

Bambool
桂竹 *makino bamboo*
45(L) x 45(W) x 73(H) cm

流沙 **Hourglass**
桂竹、鏡 *makino bamboo, mirror*

天工職人／MASTER ARTISANS

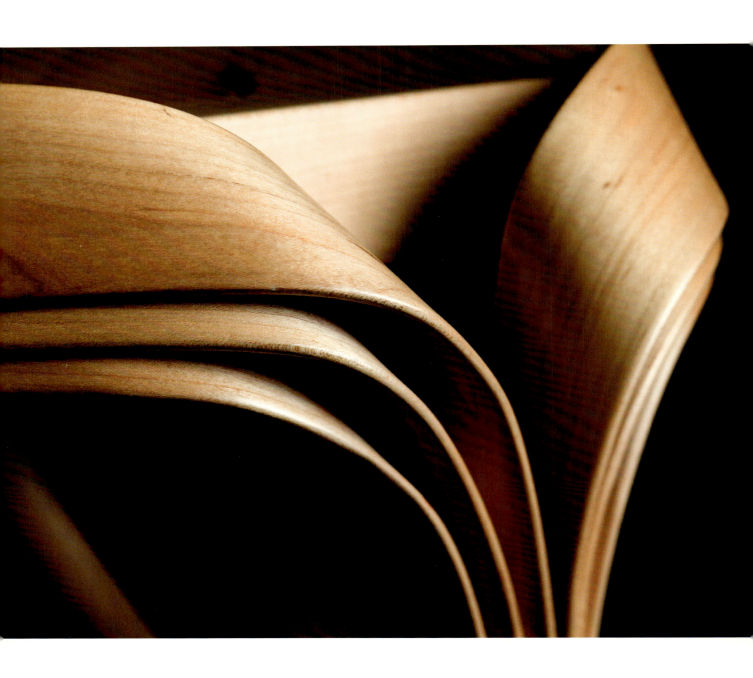

創新傢俱工藝

呂岳軒

國立屏東科技大學木材科學與設計系畢業，呂岳軒創作出以「誘惑」為命題的傢俱，以彈性較佳的楓木為材質，經長時間蒸軟、彎曲、黏貼疊製而成，工序繁複細膩，充分展現出年輕人不拘泥傳統的創新力，為傢俱創作導入新思維。

誘惑 Temptation
楓木、胡桃木 *maple, walnut*
200(L) x 160(W) x 130(H) cm

天工職人／MASTER ARTISANS

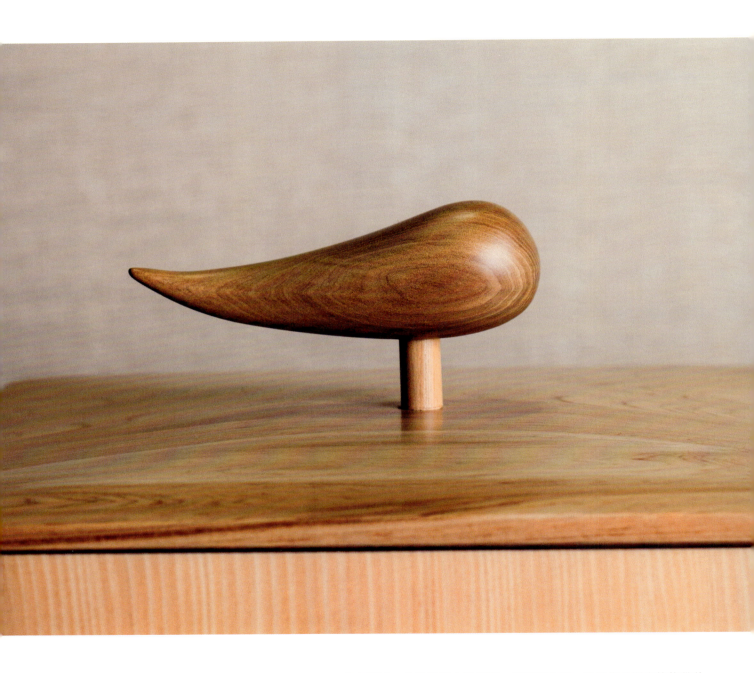

創新傢俱工藝

魏忠科

「木語漆」品牌創辦人魏忠科，從事細木作、漆器作品開發傢飾設計，鍾愛原木的溫潤質感，自學木工技法創作出具有藝術性的手感傢俱。以實用及美感為創作的主軸核心，體現自然環保的生活態度，表達對材料惜物戀物的珍惜情感。

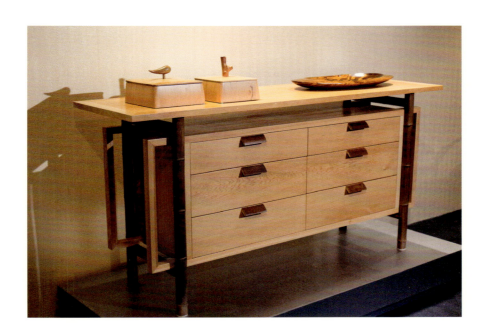

檜家族 168　Hinoki Family 168
臺灣扁柏，四方竹(腳)，煙薰竹(把手)
Taiwan Hinoki, square bamboo (legs), smoked bamboo (handle)
200(L) x 160(W) x 130(H) cm

雙圓　Double Circle
臺灣扁柏 *Taiwan Hinoki*

藏　Hide
臺灣扁柏 *Taiwan Hinoki*

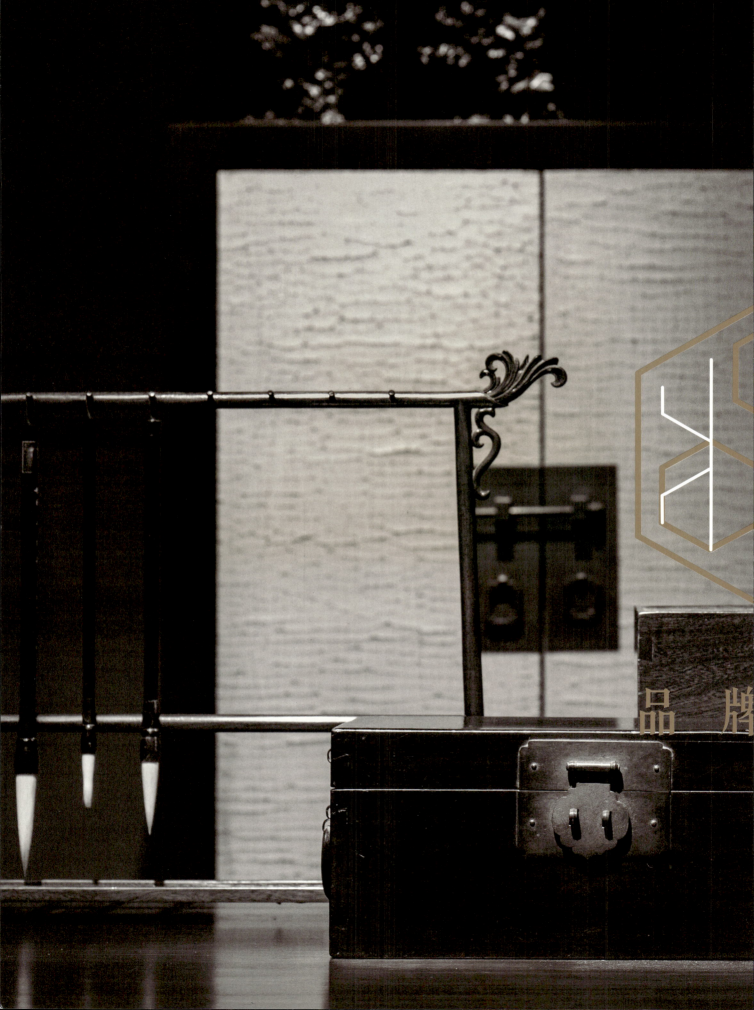
品 牌

經營品牌，帶動產業高產值
Artisanal Brands,
a Strategy to Drive Value Creation

品牌，是讓產業升級、創意加值的催化劑。好的品牌能夠帶動產業升級，進而驅動工藝發展朝向產業化發展的可能，品牌工藝師扮演著帶動產業良性循環的關鍵角色，「工藝職人－品牌－產業」三者相輔相成，互為表裡。

因此，除了展出「經典工藝師」與「時尚工藝師」個人精采作品，本展區特別邀請已經在市場上成功創立的品牌，以及具有創造工藝產值的線上品牌參展，提供工藝師與設計師們思考未來如何將「作品」轉換為具有產值的「產品」，品牌的經營需要人力與物力的長期投注，兩者之間該如何取得平衡，藉以產生交流互動與經驗傳承。此次邀請的工藝品牌包含：無垢茶活、春在生活、臺華窯、朱的寶飾、東裝等，在工藝的商業價值市場具有影響力、能帶動產業發展的工藝品牌。

Creating a brand that is known by the public can be a catalyst for increasing the value of products in the marketplace, and building strong brands can be a driving force in industrial development. Therefore artisans who create their own brands play a key role in this virtuous cycle. All three elements—artisans, brand and industry are important and mutually complement one another.

In addition to showcasing artisans in the areas of "classical" and "trendsetting" fine crafts, special invitations have been given to artisans who have created value by successfully building their own brand names, or developing a presence by exhibiting on-line. These new approaches raise questions about how to manage the brand creation and value enhancement process, including how to turn a "work" into a "product", how to balance the interaction between the two, and how to obtain and manage the human and material resources needed to develop the brand long term. The exhibiting artisans who have created their own brands are Legend Lin Teaism, Chunzai Collection, Tai Hua Pottery, Chullery and Silzence. These brands have established influential commercial positions and have played leading roles in promoting the development of the fine crafts industry.

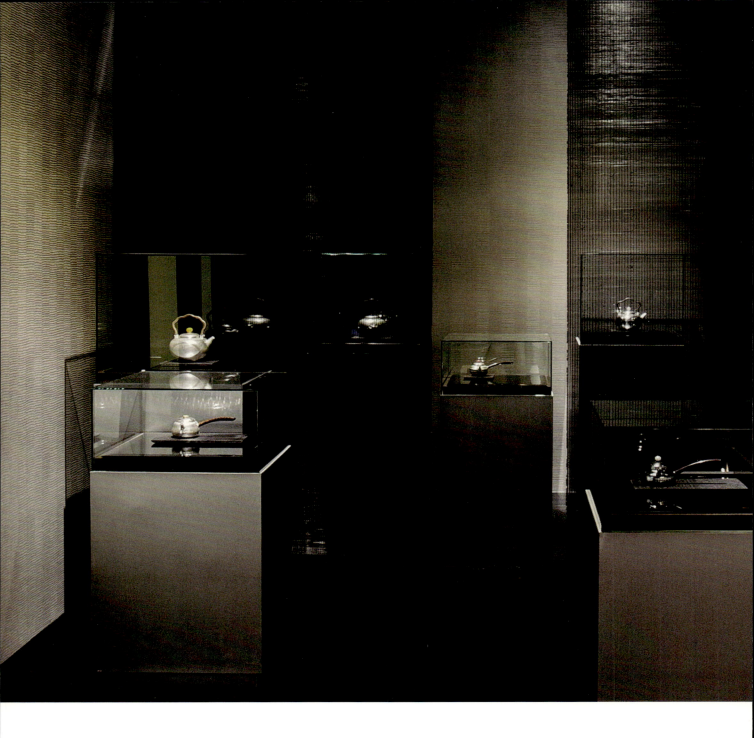

無垢茶活
Legend Lin Teaism

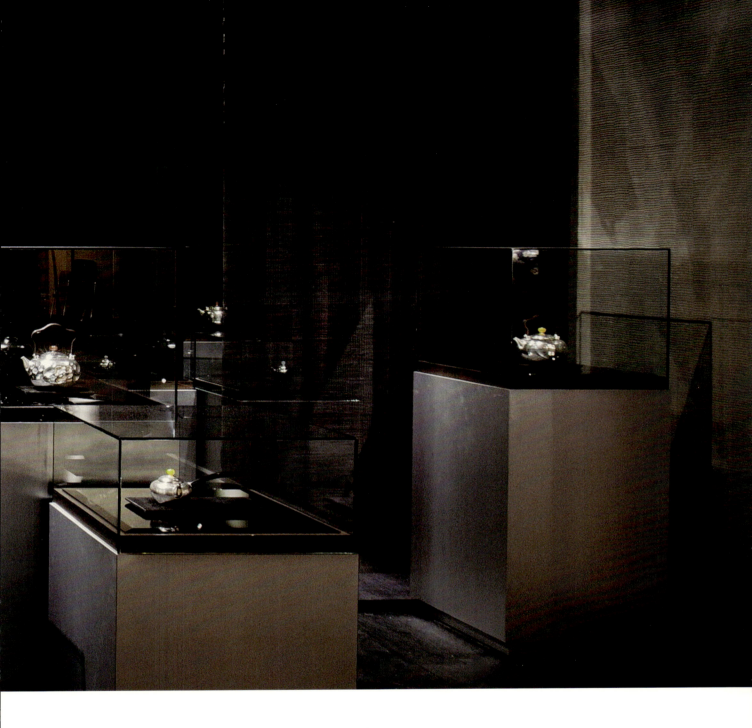

源起於 2009 年,「無垢茶活」的主人陳念舟亦是無垢舞蹈劇場的團長,更因醉心品茗久經琢磨,起而以金銀材製作壺器。晚唐茶書《十六湯品》:「湯器之不可舍金銀…」,基於遵古又創建,從東方的美學觀出發,尋找一種品茗的質感及形式,由於熱愛並鑽研歷代的藝術文明成就,堆疊出壺器創意的中心思想,期待領會唐宋時期茶文化最輝煌的意象,以致創作出屬於當代的「新董」。茶活壺器無論是命名、形制、構思乃至生活觸動皆以臺灣為繆思,中華傳統為基底。歷經千錘百煉的金銀壺器,展現臺灣獨特生活美學,期盼在從容自在的過程裡「品茗、沉思、對話」,在看似平淡簡約中得到圓滿。「無垢茶活」期許能創作出擁有臺灣底蘊的經典「新董」,成為豐富生活的壺器。

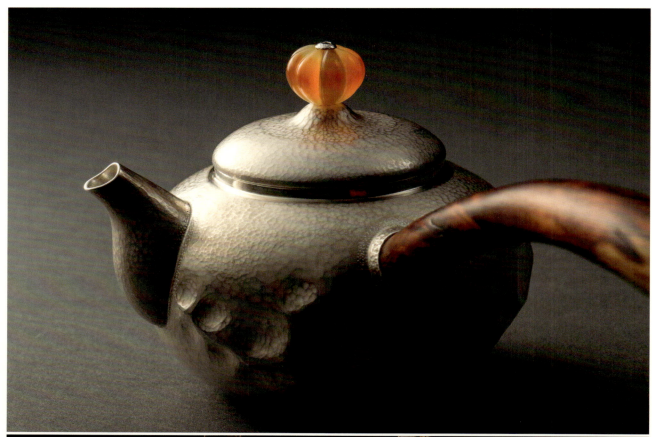
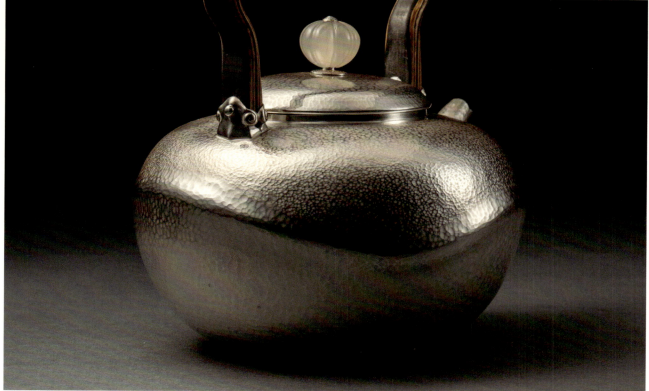

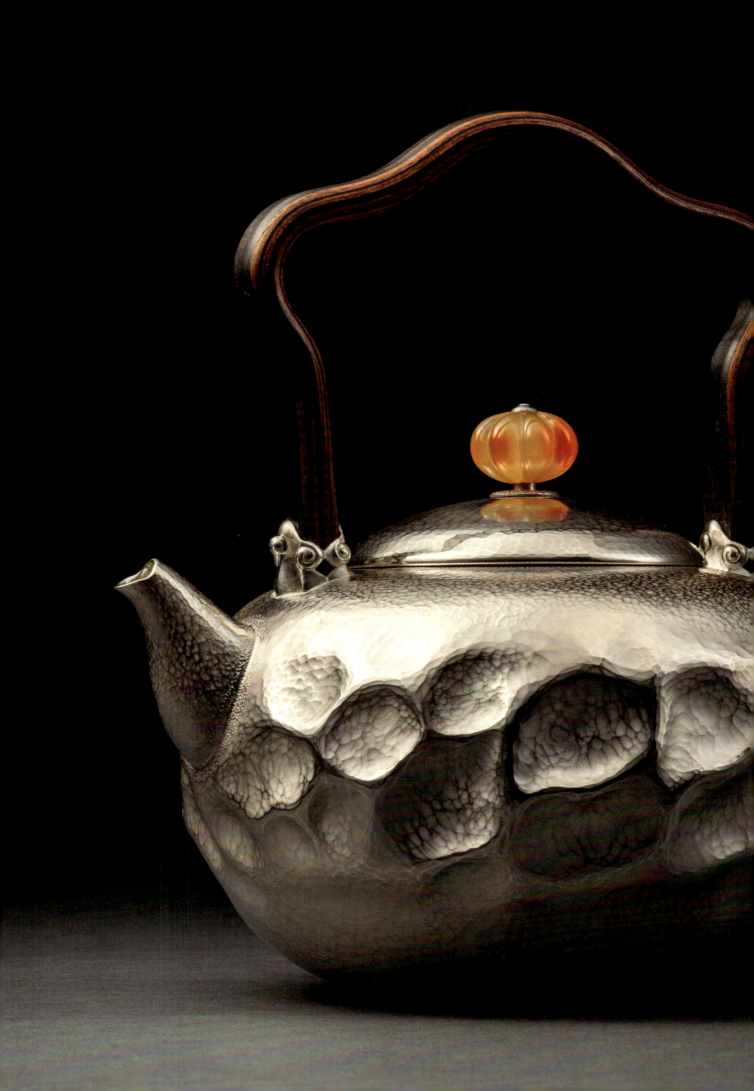

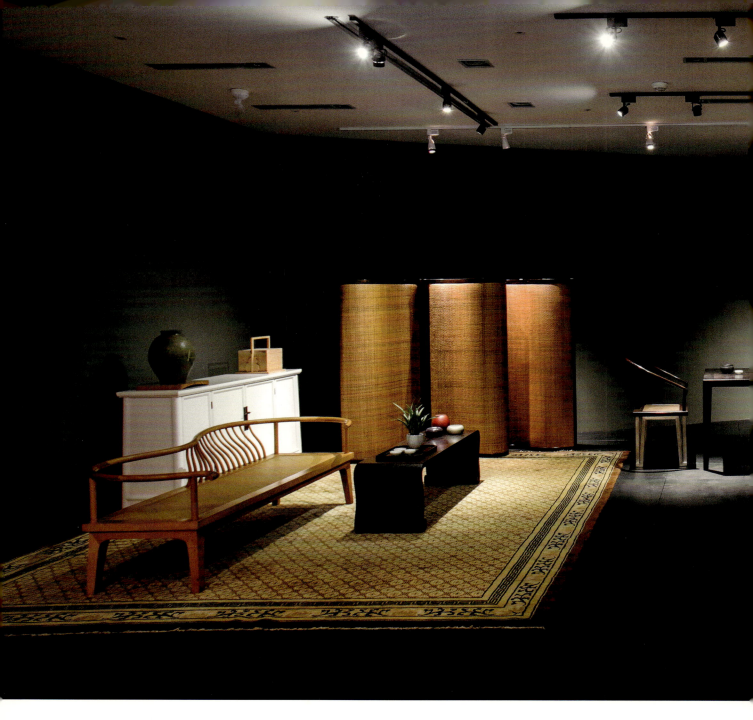

春在生活
Chunzai Collection

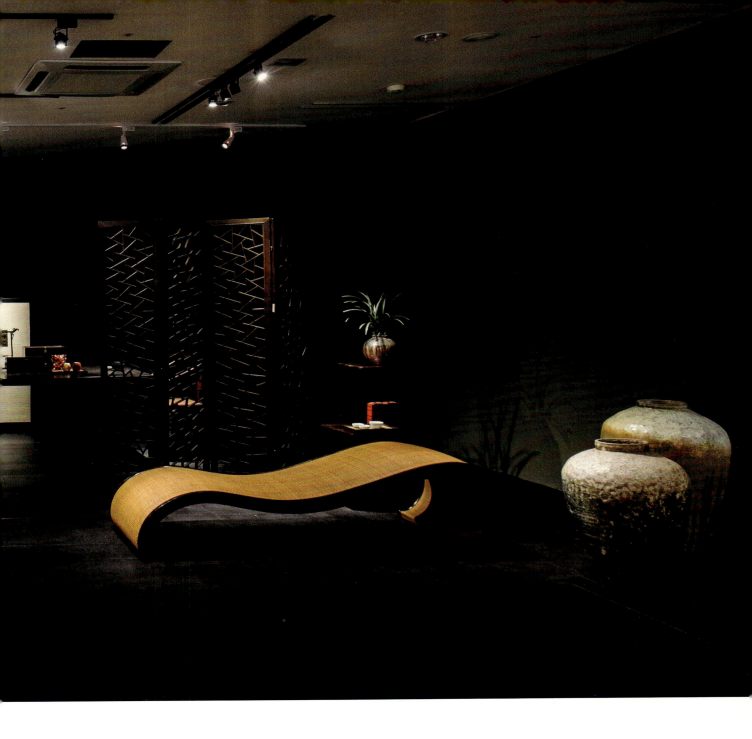

「春在生活」創立於 2004 年,來自於我們 1990 年代開始的傳統家具修復工坊,所積累出對中國木作結構、漆藤竹藝等文化之理解。經過反覆地吸收文化沉澱後所創作出的家居創意,為中國家居工藝找到全新的設計語彙,兼具著現代感的時尚線條,更散發出濃郁的人文氛圍,向世人訴說屬於這個時代的精緻生活美學經驗,從而創造當代東方人文家居的新風貌。

天工職人 / MASTER ARTISANS

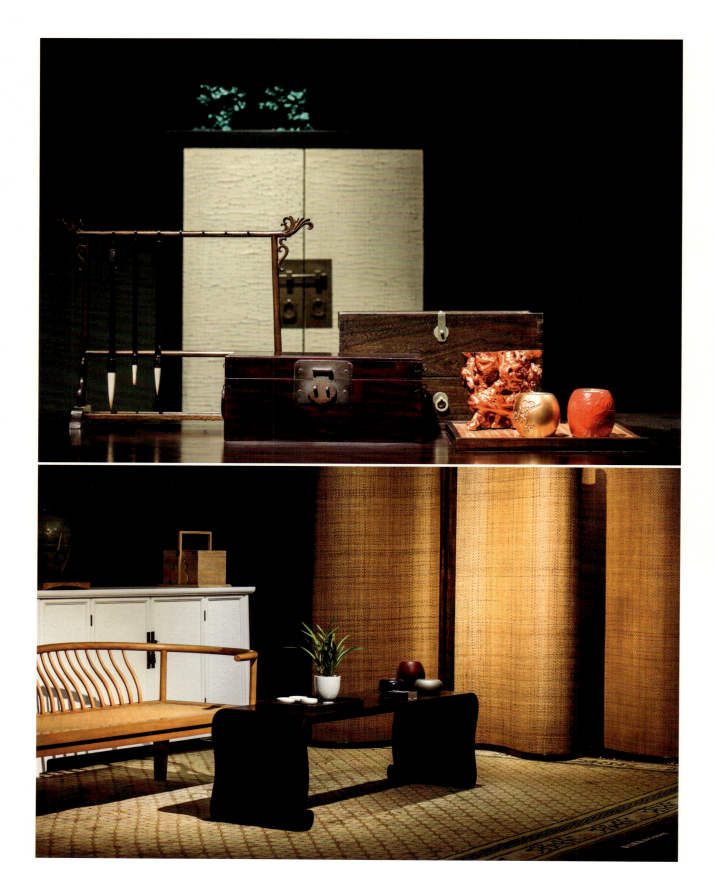

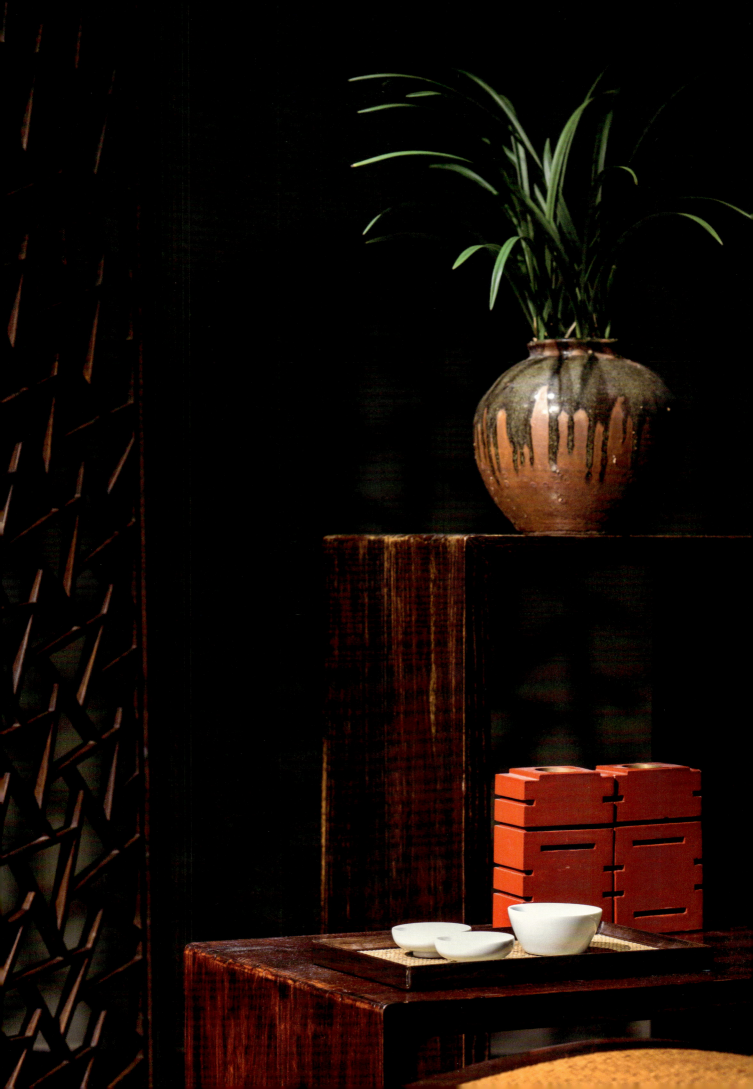

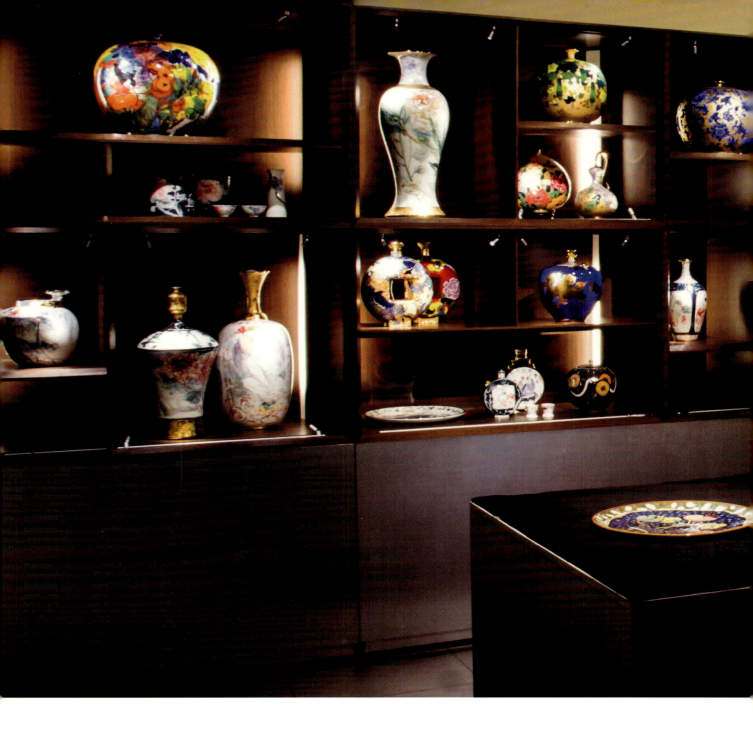

臺華窯
Tai Hua Pottery

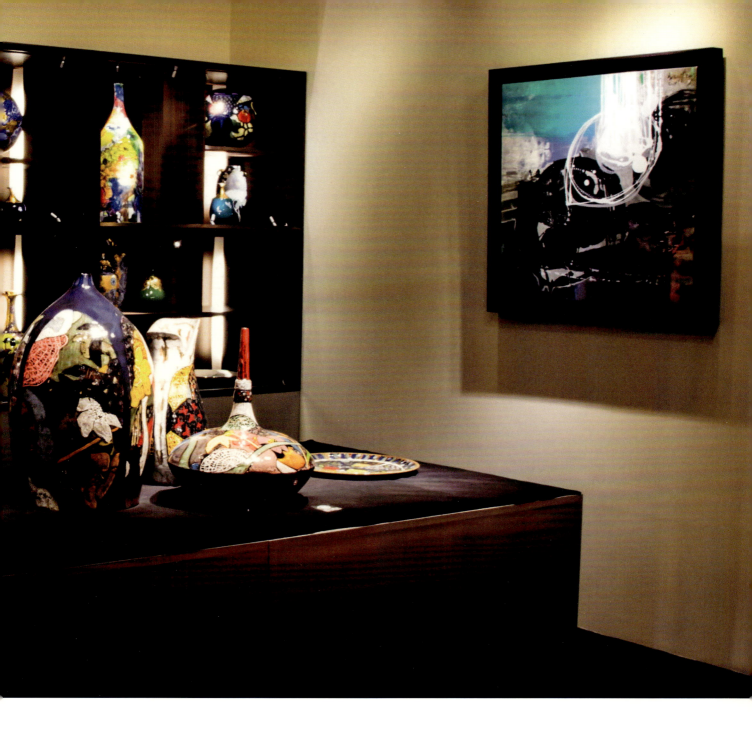

創立於 1983 年，臺華窯自成立以來秉持深耕臺灣文化的理念，以精湛的工藝技術與不斷推陳出新的創新概念，提出有別於傳統陶瓷工藝的作品。其日用瓷器與陳設瓷器的研發能力日新月異，不斷與工藝匠師們切磋交流，創造彩瓷藝術與設計的新境界，開創出魅力獨特的高感質精品。不僅創造臺灣瓷器的新風華，更成就屬於臺灣高感質的品牌價值。

天工職人／MASTER ARTISANS

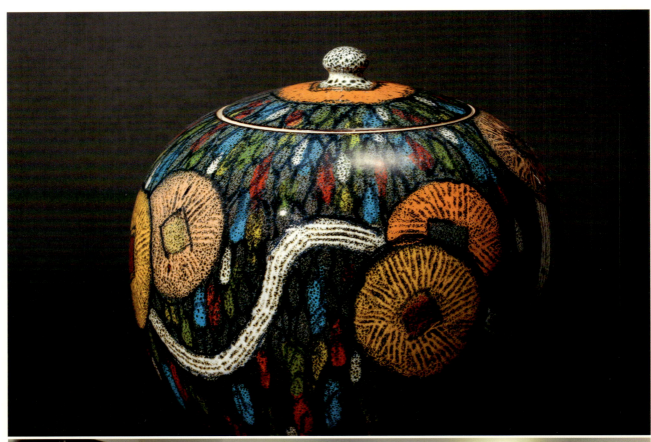

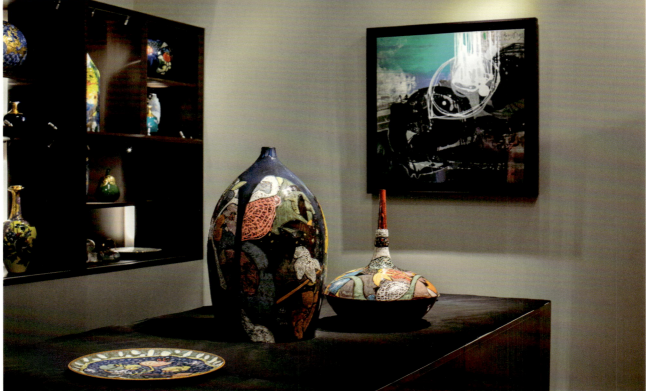

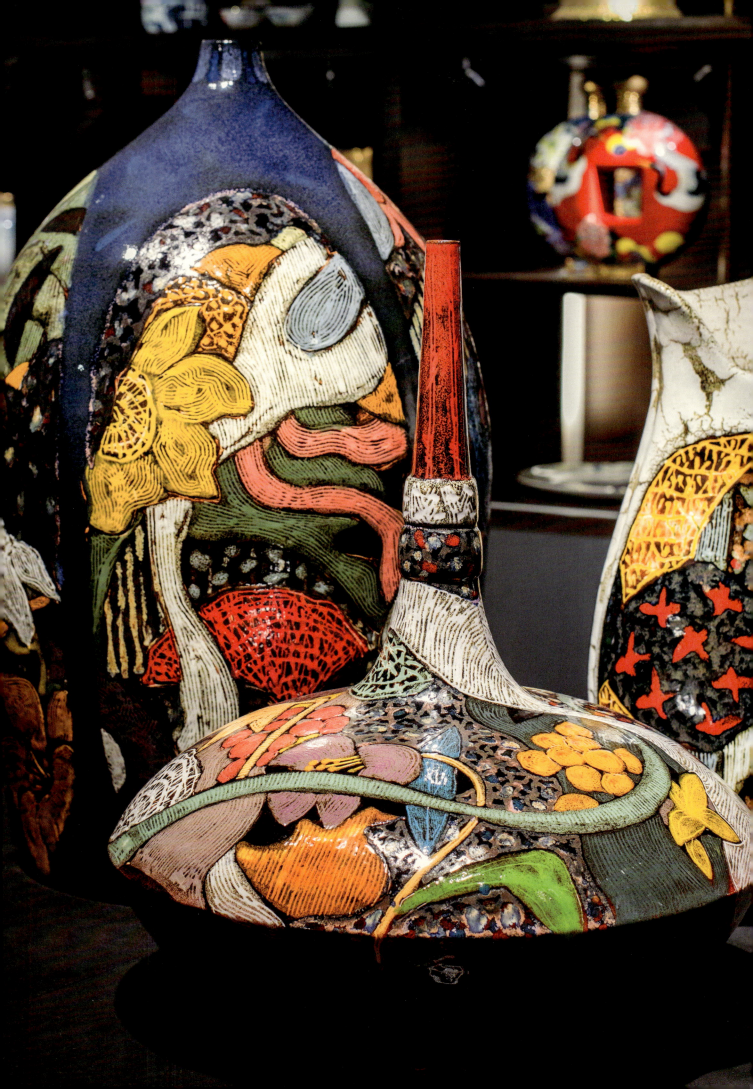

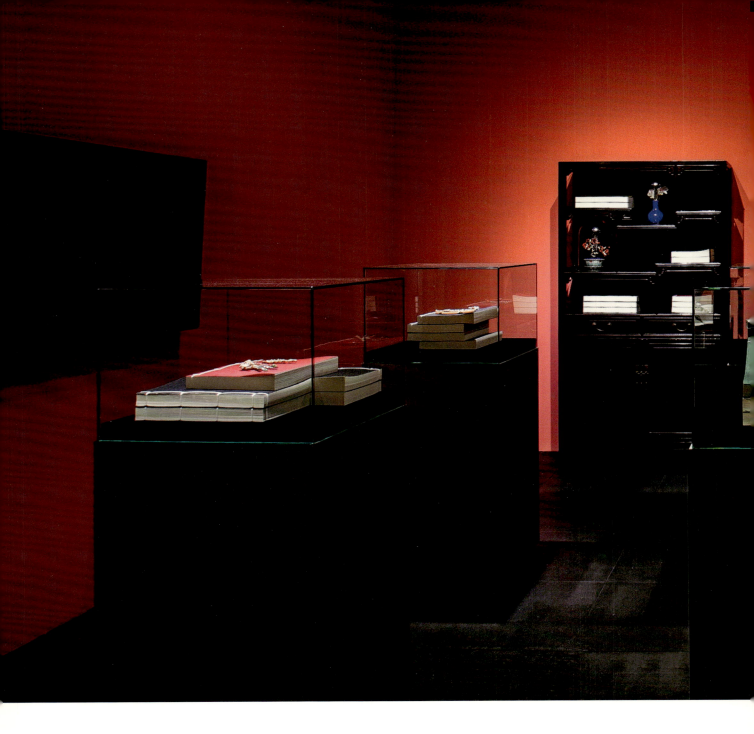

朱的寶飾
Chullery

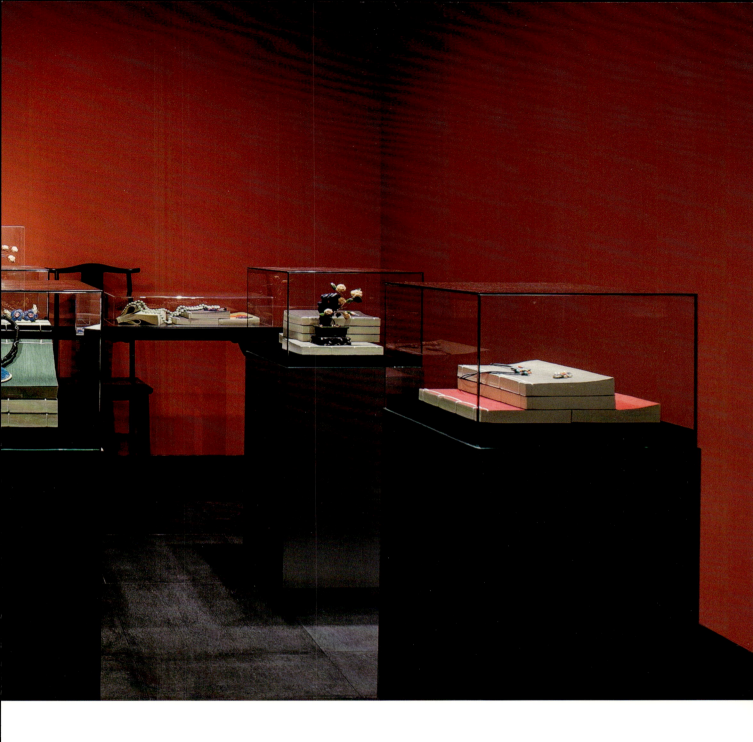

創立於 1992 年，由林芳朱所領導的設計師品牌珠寶公司，從事藝術及古董珠寶設計，現與國立故宮博物院雙品牌合作，以「故宮新藝，文化珠寶」為宗旨，將珍藏的國寶轉換設計為藝術珠寶，呈現裝飾性、文化性及故事性的國寶精品。「朱的寶飾」珠寶富涵人文思維，匯聚了當代藝術史寶飾的典範，蘊含深厚文化底蘊，將古典之美、文化之美推廣到世界各地。

天工職人／MASTER ARTISANS

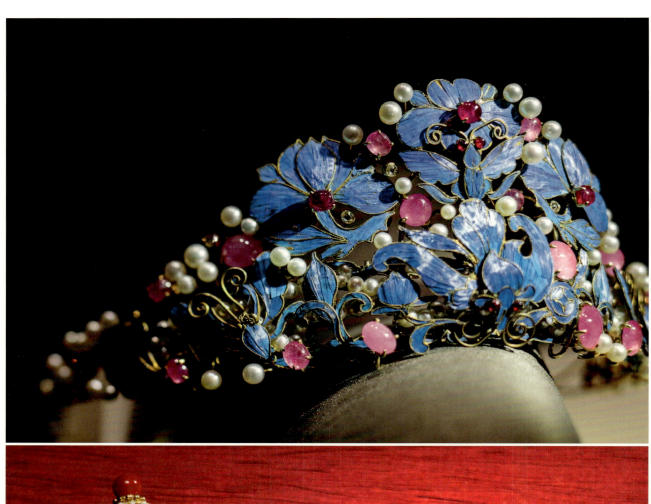

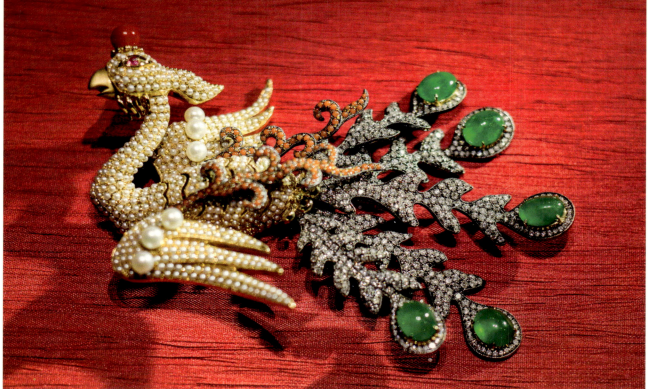

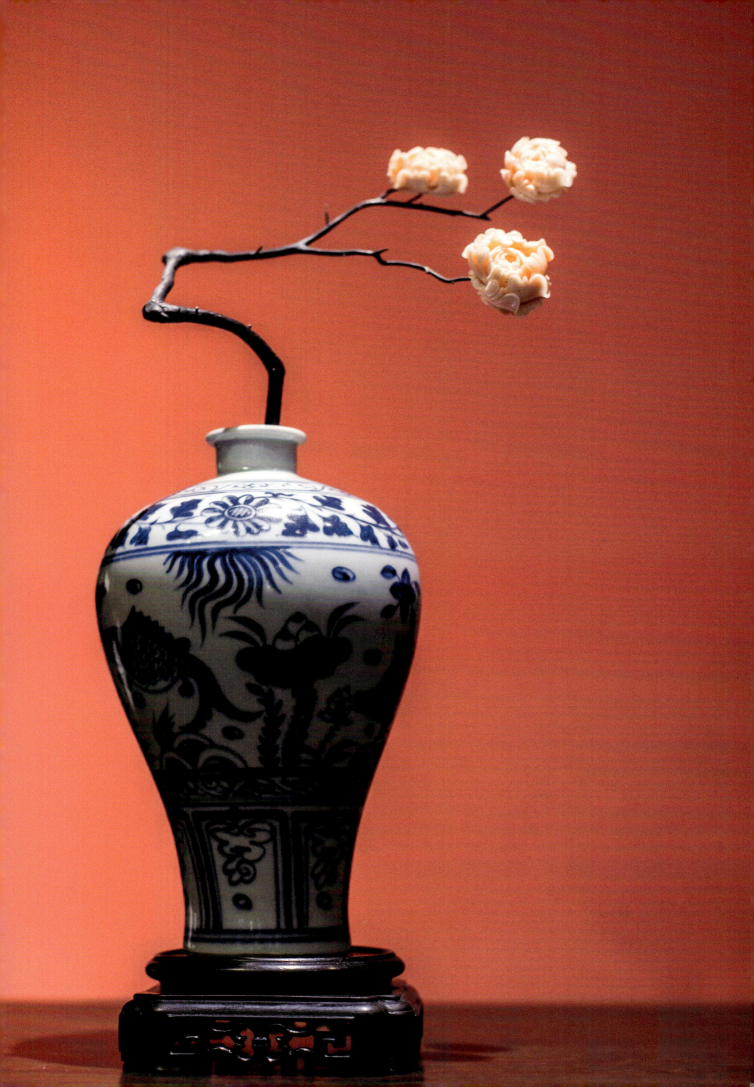

東裝

Silzence men

凡世的多是一種煩事，俗塵的少是一種贖成，從簡單到簡單很簡單，從簡單到純粹不簡單，少即是多，多即是少，我要的比多少少更多！

「東裝」以自身的東方文化為底蘊，別看一縷時光清雋，中觀盈袖長風於衣帶翩 然間，簡單俐落著宋明文化素雅時尚，拂袖懷文抱質重現華風，美學質地帶出華 人禪意思維的卑謙、和諧與真實，細緻華麗著感質精淬與人文美學，穿上文化自 信展現品味獨具的優雅氣息，賦予時代東精神，找到經典就不害怕流行！

天工職人／MASTER ARTISANS

工藝大觀
FINE CRAFTS

物之為用，跳脫形制框架之外
Thinking Outside of the Box, Being Creative in a Pragmatic Way

「工藝大觀」物意區，著眼於「物」的創作，選品從庶民生活出發，透過具有深層意涵的主題設計，重新定義「器物」的命題，巧妙組合具有同質性卻各有巧思變化的工藝單品。近年來文創風起，工藝作品因加入文化語彙的設計而展現創新面貌，「工藝大觀」的展出舞臺就是為了扶植與鼓勵更多創作者從生活中出發，傳遞創作者對臺灣土地的情感、對常民生活的關注、對民俗文化的重視，同時也承載著對工藝的堅持精神。展區設計活潑，饒富雅趣的古提籃化作新穎的展臺，洋溢著蓬勃的文化能量，同時也帶給民眾探尋工藝的巡遊樂趣。工藝大觀選品分為六大系列共約 30 件工藝展品。

The "Fine Crafts" section focuses on the process of creation. The selected fine crafts are mostly from our daily life, yet the intent of the theme is to contribute deeper meanings in an effort to re-define the perception of the "objects". That is, different objects can share the same characteristics yet be contrasted in ingenious ways. Recent changes in the vocabulary of culture and design have transformed the ability to express these new outlooks. Therefore, this section was purposely designed to encourage more creative designs that relate to ordinary life. At the same time it also creates a setting for artisans to express their sentimental feelings towards their homeland of Taiwan, to attract the attention of ordinary people and folk culture, and primarily to demonstrate their adherence to the spirit of fine craft creation. With arrangements like turning antique baskets into display settings full of vibrant cultural energy, the designs of the exhibition areas are creative and surprising. They draw viewers along on a pleasurable journey of fine crafts exploration. The "Fine Crafts" section is divided into six areas with about thirty exhibits.

工藝大觀／FINE CRAFTS

窗彩明
Memories from iron

記憶中的臺灣傳統美好年代，散發一股悠然自在的生活氣息。近年來傳統文化興起復古風潮，昔日的鐵花窗、玻璃窗等具有文化鄉愁的文創品赫然成為顯學。都新羽、賴滿軍、王耀樟這三位新銳設計師，透過鐵窗彎鐵技藝，尋找昔日街道巷弄中的鐵花窗記憶，大膽改造成為檯燈、座椅、邊桌等生活傢俱。源自於傳統的手造金屬工藝，經過了巧手轉換讓逐漸失傳的鐵窗技藝，化身成為具有鐵鑄手感的現代傢俱，賦予新的美學詮釋與生活運用的價值。天晴設計事務所總監易瑋勝所設計的鐵窗椅，則透過簡潔並調整圓潤和諧的線條，保留傳統製作方法，用工藝解說鄉愁。

鐵窗椅 PB1　　　天晴設計｜鐵
鐵窗印象　　　都新羽、賴滿軍、王耀樟｜黑鐵手工鍛造、粉體烤漆

天下知
Knowledge with pragmatism

當時代的書寫工具轉變,傳統的筆墨紙硯透過文化創意轉換,重新進入現代生活,體現迥然不同的用途與趣味。毛筆除了書寫,還能變身為甚麼?新生活品牌「喜器 CiCHi」,由臺灣知名設計師李尉郎、易瑋勝共同領軍,融入深刻的人文思想,巧妙運用文房墨寶等特質,把毛筆變筷子,將軟筆字變硬筆字,還有沾喜氣的碟筷組,使文房四寶改頭換面,優雅地融入生活中。侯淵堂以 Poodehii 為品牌設計出東西方文化並蓄的「文昌筆」,以時尚科技運用東方的概念經營創作,讓文創點燃生活趣味。

1	2
3	4

1　文昌筆　　　Poodehii｜臺灣玉、原子筆
2　墨宴餐具組　天晴設計｜陶瓷、木頭、布
3　沾喜碟筷組　喜器 CiCHi｜陶瓷、木頭、金屬、橡膠
4　毛筆筆 II　　喜器 CiCHi｜竹、皮套

工藝大觀／FINE CRAFTS

敬天地
Heaven and earth

　　東方信仰文化的本質是虔誠崇敬的,敬神祭祖是生活的一部分,原本用於禮敬天地神的元素物件,以創意重新解構既有符碼,探尋與展現新的文化歷史與信仰意義。「土干創意 Tocca Design」發展出保佑系列金紙筆記本等與信仰有關的創作,尋求多元文化與傳統現代衝撞下的創意產品。陳鴻輝結合道教信仰推出「玄帝瓷杯」馬克杯,將清淨水符印於杯面,產生喝水就能有符咒的效果概念融入作品,神明也能跟上潮流。「甘樂文創」用媽祖繞境施放後的犁炮屑製作紅包袋,傳遞平安福佑之意,延伸崇敬宗教信仰文化,融入順天應人的關係。「生活起物 ink」則讓虔誠祭拜問事的擲筊變身為橡皮擦,讓信仰走進年輕世代的世界,真正做到傳統與現代融合。

1	2
3	4

1　金紙筆記本　　　土于創意 Tocca Design｜牛皮紙
2　玄帝瓷杯　　　　陳鴻輝｜瓷
3　炮紙紅包袋　　　甘樂文創｜炮屑手工紙
4　筊橡皮擦　　　　生活起物 ink｜無毒 (PVC free) 橡皮擦

工藝大觀／FINE CRAFTS

敬天地
Heaven and earth

「群秀文化」以紅龜粿的形狀為發想，設計出印上喜、壽兩字的「臺灣紅」色彩抱枕，蘊涵在地文化幸福。「紙，有唯一」古佳峻設計師傳達纖維、紙漿的可塑性與傳統工藝的價值性，以擬真的壽桃、彎桃、花糕籃等造型，讓傳統祝福的意象可以永久保存傳遞。「TZULAï 厝內」復刻美好生活，傳統的紅龜粿變成裝盛糕點的拖盤，讓生活多變有趣。「二喜 HEE Porcelain」將傳統節慶祭典上常出現的紅龜粿，選用圖樣化為餐桌淺盤、湯匙與筷架的嶄新元素，期能汲取福祿恆久的好兆頭。

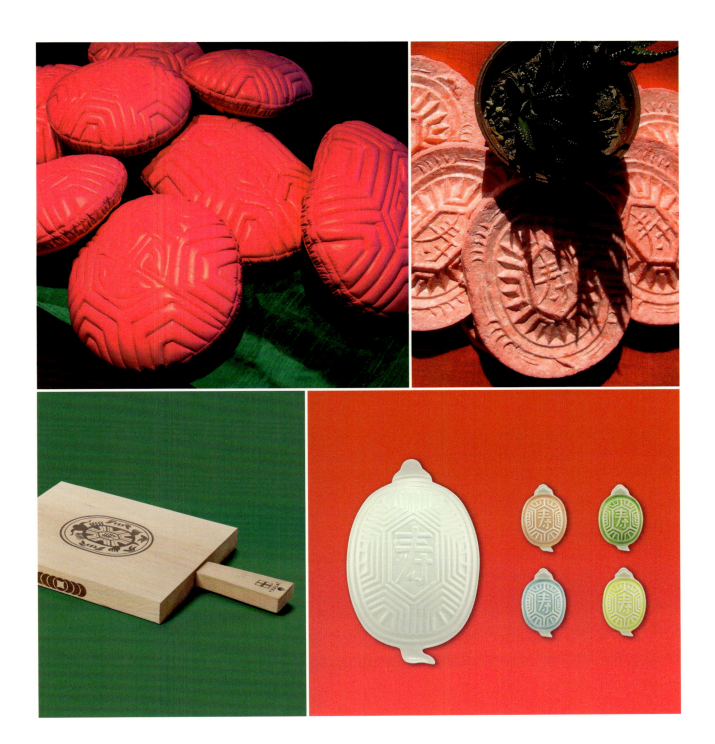

5	6
7	8

5　紅龜粿抱枕　　群秀文化｜皮革
6　紙塑紅龜粿　　紙，有唯一｜紙漿
7　大紅龜粿盤　　TZULAï 厝內｜櫸木
8　久，KU 龜淺盤　二喜 HEE Porcelain｜瓷器

工藝大觀／FINE CRAFTS

一聲白
Sounds of whiteness

展品包含洋溢食材趣味的豆腐椅、豆腐凳子、豆福杯、豆腐盤等創意工藝品。由設計師李尉郎所設計的豆腐杯，使用上充滿趣味；來自DOMO達摩設計的豆腐吧檯椅是設計大展中的常勝軍，取法日常生活意象與乘坐體驗交融，是連結傳統與現代的最佳詮釋；由「TZULAï厝內」所設計的木製豆腐托盤，傳遞款款熱情，保留純樸味，一種美好生活經驗的復刻，同時也擴大了豆腐托盤的用途。

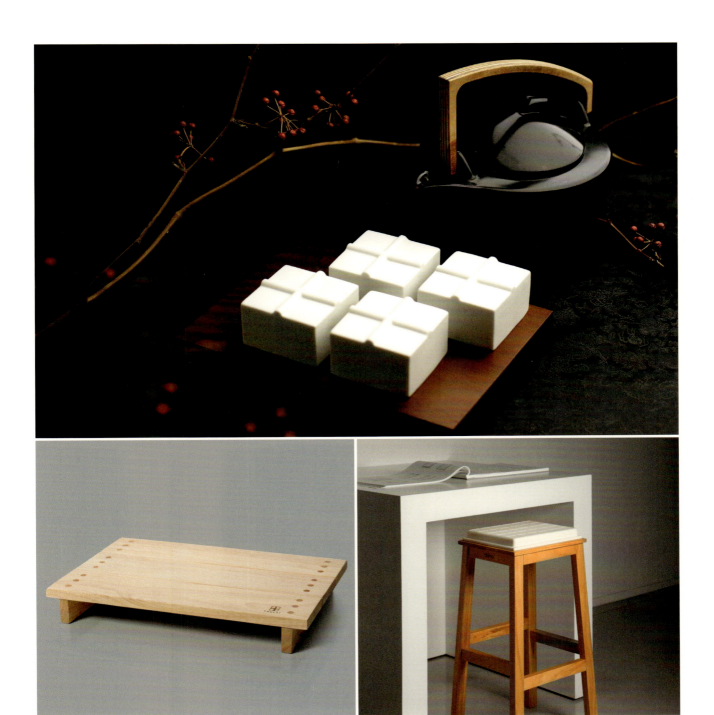

1		1	豆福杯	喜器 CiCHi｜瓷器
		2	豆腐盤	TZULAï 厝內｜橡膠木
2	3	3	豆腐吧檯椅	DOMO 達摩設計｜EVA 發泡材、松木

倚修竹
Simply just bamboo

　　竹材過去是臺灣重要的工藝材料，要讓逐漸式微沒落的竹產業浴火重生，需要善用天然竹材的特性並整合工藝師的智慧，加入創意美學元素，以傳統為基礎、新穎設計為出發，融入文創思維，發展為創新的竹製品。新銳設計師林大智和謝易帆共同設計的「清四維」、「清轉合」，利用水泥和竹子製成具有原始竹素材與現代造型風格的椅子，反思材質既有的美感細節。由禾樂工坊的林建成推出的「環竹桌椅」，以竹管材之應用，設計出線條簡約的生活傢俱，呈現竹藝現代風華。竹采藝品製作的「竹蟬茶則」，由設計師林群涵研發出竹材保青處理，造型簡約樸實，保有竹藝純粹質樸的美意。

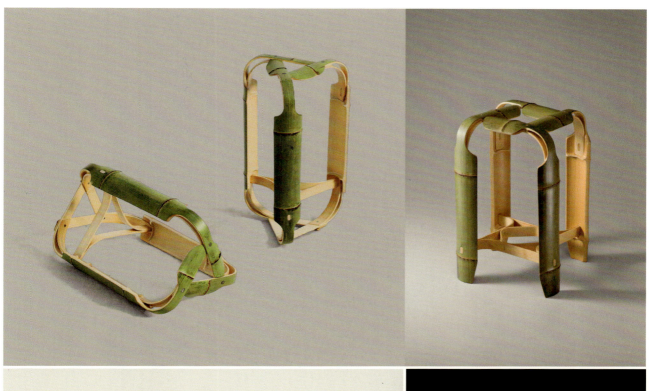

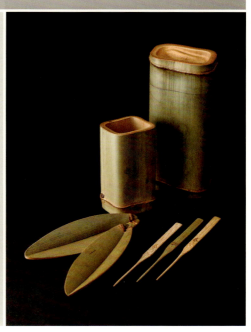

1　清四維、清轉合　　　林大智、謝易帆　｜孟宗保青竹
2　環竹桌椅　　　　　　禾樂工坊　｜竹材、玻璃
3　保青方茶罐、竹蟬茶則　竹采藝品　｜孟宗竹材

工藝大觀／FINE CRAFTS

心傳薪
Bequeath the heart

創建稻米、藺草文化永續發展新契機也能成為生活風格的新品味。坐在蕭永明、徐景亭的「豐收椅」上，感受大自然共生共榮的理念，將稻草注入常民工藝，體會土地的滋味，簡單的生活工藝就能讓社會更美好。而一張具有永續概念創造的「藺凳」是林芝帆把藺草的廢料再重新運用的創意，兼顧環保工藝的前瞻思維。回味傳統生活的「稻田捕手」椅，楊智涵運用新一代的設計觀點，以廢棄稻草繩為媒材，在彈性網布上進行編織，坐上去瞬間被濃濃稻草香擁抱，猶如於親臨田園。

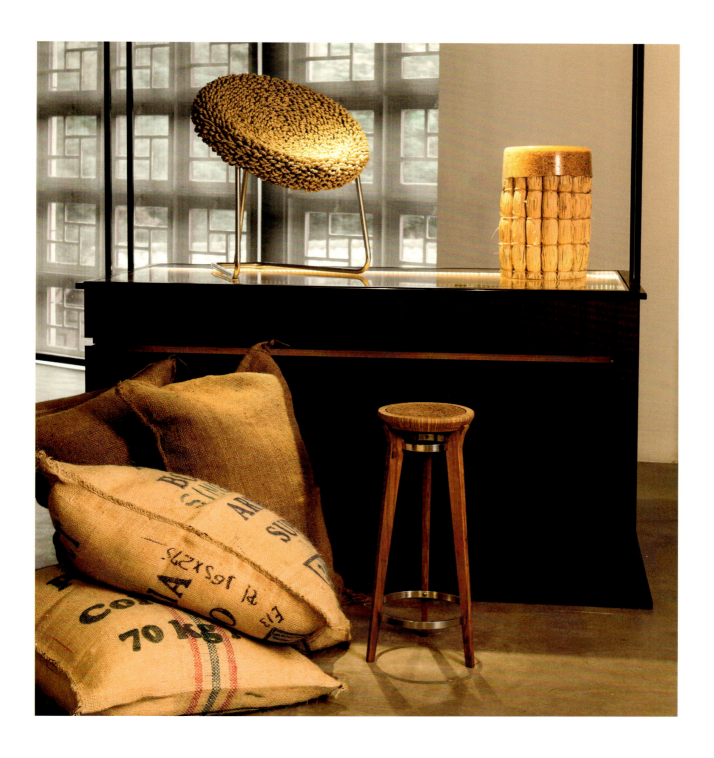

稻田捕手	楊智涵｜稻草、不鏽鋼
豐收椅	蕭永明、徐景亭｜稻草
藺凳	林芝帆｜藺草、胡桃木、金屬

展 覽 空 間

SPACE OF THE EXHIBITION

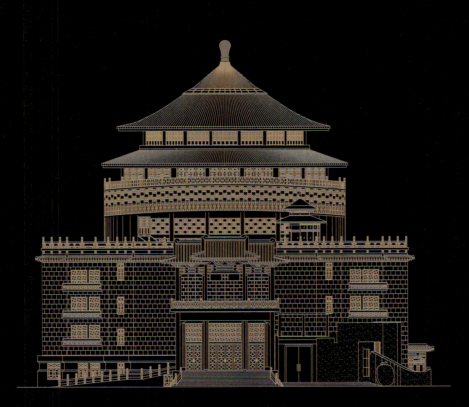

展覽空間 / SPACE OF THE EXHIBITION

三樓
3 floor

- 工藝廊

- 工藝大觀
 窗彩明 / 天下知 / 敬天地
 一聲白 / 倚竹修 / 心傳薪

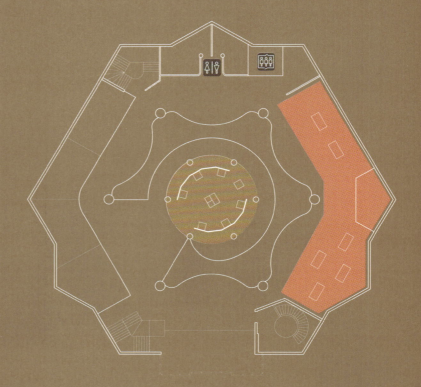

四樓
4 floor

- 經典工藝
 楊夕霞 / 林盟振
 李秉圭 / 邱錦緞
 陳景林 / 尤瑪・達陸
 蘇世雄 / 黃安福
 馮朝宗 / 吳義盛

- 時尚工藝
 謝旻玲 / 陳郁君 / 趙永惠 / 吳竟銍
 陳劭彥 / 黃嚴慶 / 鄭鈺錡 / 陳敬凱
 吳孝儒 / 王帥權 / 吳偉丞 / 廖勝文
 黃俊傑 / 周育潤 / 呂岳軒 / 魏忠科

- 品牌工藝
 無垢茶活 / 朱的寶飾 / 東裝
 春在生活 / 臺華窯

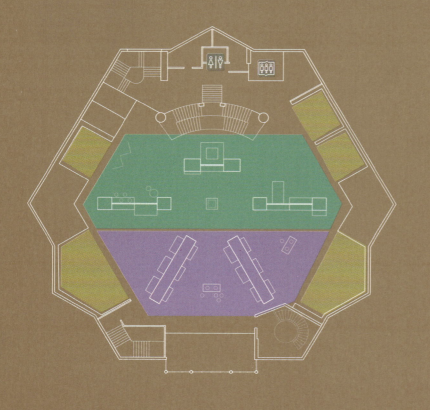

天工 當代工藝的百工百貨

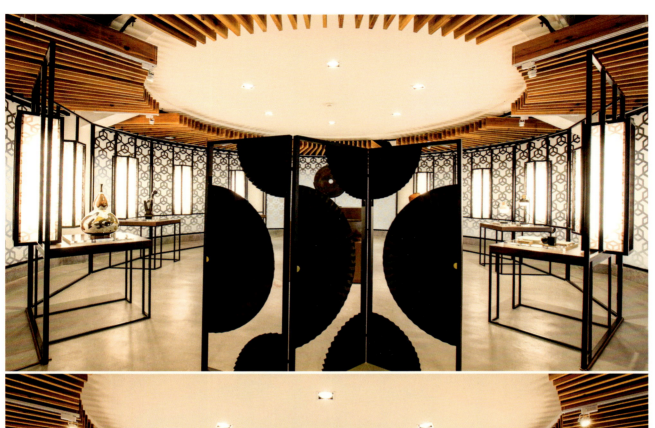

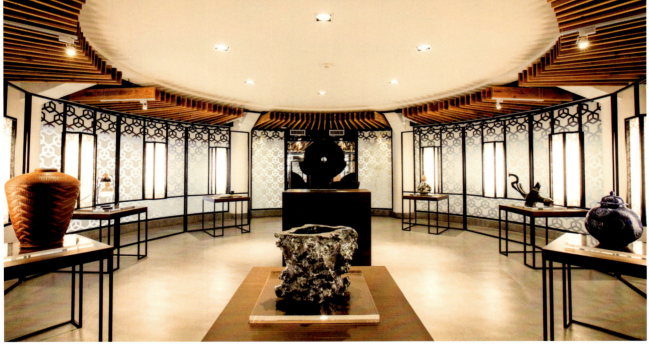

工藝廊

工藝發展的歷史脈絡源於創作者師法自然的謙卑學習，從生活中沉澱涵養為文化美學。隨著時代遞嬗與工藝技術的精良演繹，加之以多元的創新變化，從常民生活體驗出發，發展為百家爭鳴的「百工」傑作。

展覽空間／SPACE OF THE EXHIBITION

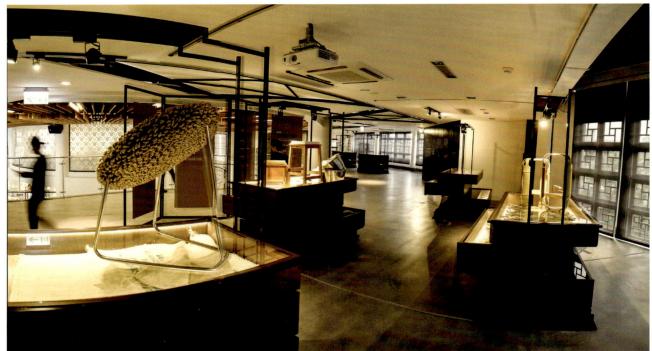

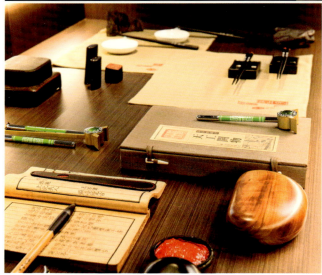

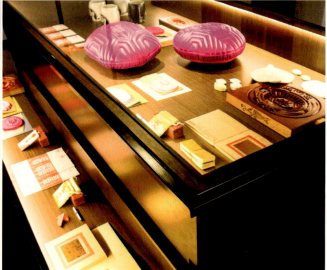

工藝大觀

尋找具有臺灣元素的創意發想，精選富含土地情感、常民生活、民俗文化精神等之系列主題，作品傳遞著對臺灣的情感，同時也承載著對工藝的堅持精神，充滿對臺灣這片土地的熱愛與活潑蓬勃之朝氣。

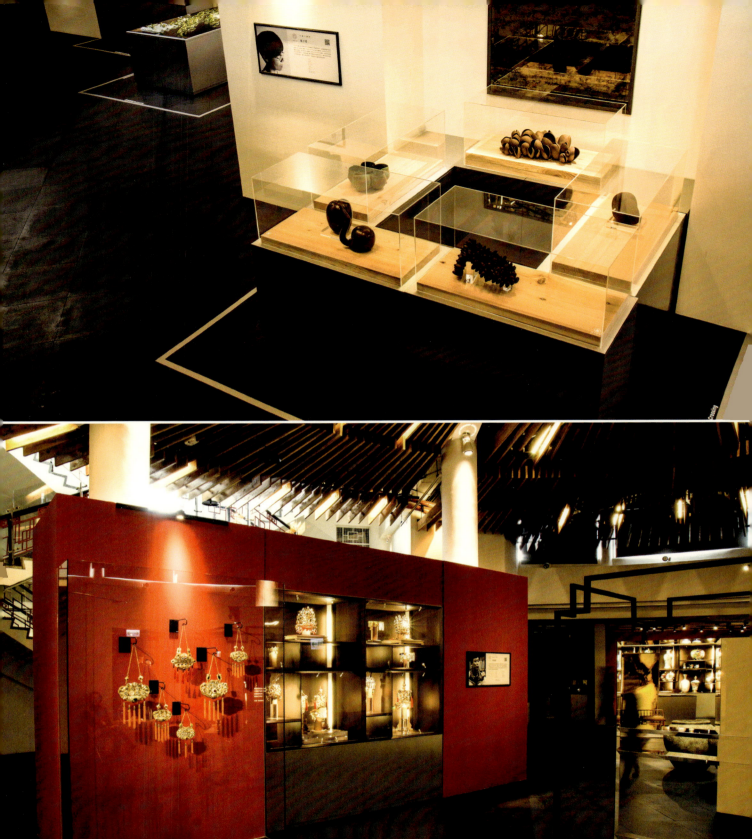

經典工藝

找到經典,就不怕流行。以「金、木、水、火、土」五大元素為分類,邀請十位資歷深厚、具有代表性的當代工藝師,呈現極致工藝成就頂尖藝術,展現亙古不變的細膩技巧與永垂不朽的工藝價值。

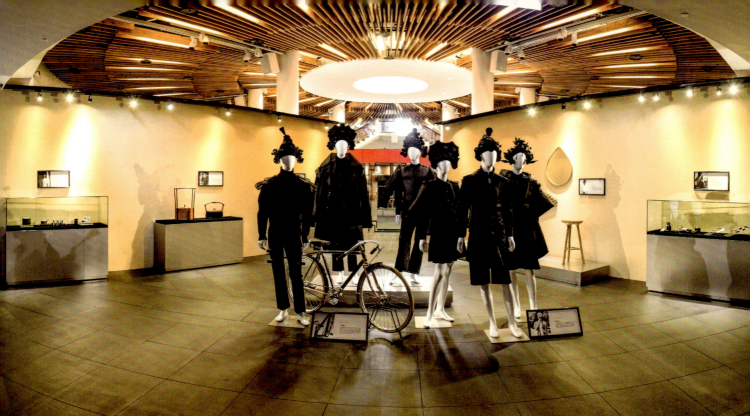

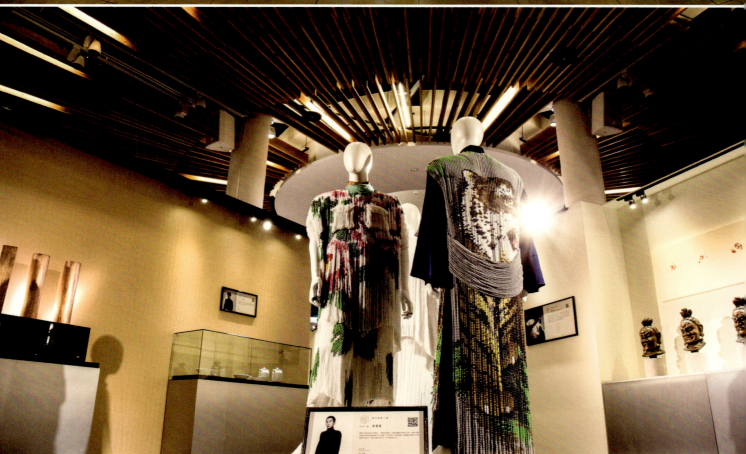

時尚工藝

時尚，拍動美麗時代新浪潮。年輕的工藝創作者師法經典工藝前輩傑出的表現也積極展現絕佳創意，翱翔文創時尚的新銳工藝師，體現時尚工藝產業發展的美感價值，引領產業創新而創造多元風格與流行趨勢。

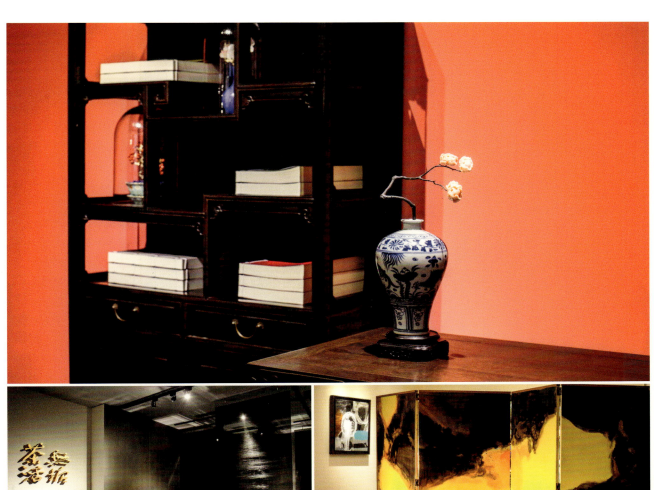

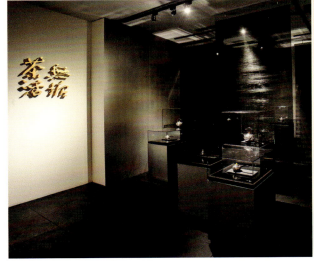

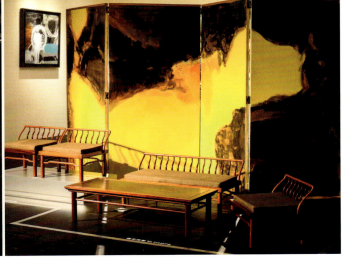

品牌工藝

品牌,產業升級創意加值。好的品牌能夠帶動產業升級產生品牌加值,「工藝職人—品牌—產業」三者相輔相成、互為表裡,「作品」轉換為具有產值的「產品」,產生交流互動及經驗之傳承。

後記 / POSTSCRIPT

禮敬天地
在天工談天

為職人撐起一片藍天，為工藝燃起一縷芳香

　　本展覽與國立臺灣工藝研究發展中心共同策劃，擔任本次「天工」大展策展人，身負重任憑藉著墨於職人堅毅不拔的信念，以百工百貨的型態創造時下當代工藝流行。近年來持續推動蛻變中臺灣文化為元素的策展，歷今已策劃多達五十多場展覽，從「2010 失落的百工」探尋即將消逝的傳統產業、「2011 果然臺灣」感念果農辛勤栽植的農民精神、「2013 信念臺灣」傳遞工藝師、設計師及學生創造臺灣文化的普世價值、「2013 玉質臺灣」彰顯臺灣原生玉石的精緻工匠技藝、「2015 美食展」提倡飲食美學與精選食材的料理職人精神。

　　每次的展出所秉持的一貫精神與態度，就是堅持與雋永的「職人魂」，如何用取之於天地的材料，透過人工巧妙設計展現不同的作品生命，此次擘劃「天工」大展，特別敬邀經典、時尚、品牌等將近 50 位橫跨產業與跨世代的天工職人，以及著眼於物的工藝大觀，成就一場工藝與時尚的美學饗宴。在擔任學校畢業專題總指導老師的時候，從「失落的百工」到「職人誌」，不斷為職人發聲，讓這些一輩子只做一件事的職人及其精神能夠被外界看到。本次「天工」大展期許從教育著手，帶領莘莘學子體驗職人精神，談傳統工藝與現代創意思維之相乘效益，帶領年輕設計師領略臺灣傳統工藝的設計美學、傳承職人精神。

　　此次展覽策畫，除了彰顯臺灣工藝「傳統精粹」的質地之美、造型結構之美、人文底蘊之美，在策展同時也期盼透過展出讓更多人理解臺灣工藝的深度與廣度，傳統工藝有種潛藏、深化的魅力，是社會歷史的濃縮脈絡，應去尋找在地情感的態度，挖掘工藝師嚴謹講究的手藝與文化薰陶，這才是探討職人精神的根本。如何保存發揚自身的文化並珍惜感念，讓新一輩能夠感受敬天禮地的美好生活，及擁有嚴謹、專業、用心、負責的態度，學習體會珍貴傳承的頂真精神。

極致工藝　細緻美學

　　身為一個具有使命感的策展人，策劃展覽冀望提醒新一輩的年輕人：「我們居住的臺灣是一塊很珍貴的土地，也是獨一無二的寶島，應該更珍愛疼惜自己的文化、真實地接納感知，做自己的主人。」臺灣最美的風景其實是人，因為「人」所以感人，因此無論是關心農業、產業到探索職人精神都必須要有自己的文化，透過策展這個動作傳遞出去。透過「天工」大展，將全面性呈現來自臺灣各地及不同領域，傳承各代的工藝師精湛技藝的工藝品，展覽集結精選傳統工藝和當代工藝設計產品，不但融合極具手感的傳統工藝技法，並結合新潮時尚的創新設計思維，原本即將消逝的傳統工藝蛻變成為能引領潮流的文創產品，且成功的創建自有品牌，在國際皆屢獲青睞及各界好評。

本次展出之工藝品範圍相當多元廣泛，來自各領域的工藝師，將傳承地方傳統工藝的文化精神融入設計，以慧心工巧的精湛傳統工藝技法，打造當代詮釋新語意，藉由超乎常人的細心與耐力，維護傳承先人智慧累積的珍貴技藝。也如同我長期以來對於推動展覽內容，盼工藝之保存、繼承、創新及省思方面，能落實發揚工藝生活化之目標，並融入歷史文化意義，引介民眾生活機能與美感上的需求，我更期許創新概念的教育能激發出臺灣工藝產值，提升產業競爭力及全民美學素養。

　　「天工」概念是來自各領域工藝技術的總結，在臺灣長遠的工藝史的歲月裡，不斷地積累演化至今。展區「天工職人」將主題圍繞著各樣工藝元素的氣息，展出以各項工藝技術的交互切磋所碰撞出的璀璨火花，「因人造物」的技藝，以各種形態多元的蓄積能量呈現，傳遞巧奪天工技法、舞出工藝極致之美；「工藝大觀」物意區呈現優質工藝設計品，打造「藝術即生活」及「生活即藝術」的品味哲學，讓臺灣工藝發展能有更多元的發展空間。做為一個推動者的角色與使命就是透過在地精神引薦國際新知，向世界展現臺灣傳統工藝美學延展創新設計的軟實力，打造跨時代風華的感質經典！

環環相結　絲絲入扣

　　「臺北當代工藝設計分館」仿天壇形式的建築，是幢充滿文化信仰及藝術之美的殿堂，旨在推廣工藝美學、培養藝文專業並深化文化藝術教育紮根。「天工」呼應「天壇」的磅礡氣勢，代表工藝之「天工開物・巧奪天工」精神內涵，傳遞工藝匠人的堅持與執著。融合著如同百貨公司般的展現方式，工藝呈現出具時尚氛圍的工藝精品，這場盛宴將顛覆一般人對工藝即傳統的認知，各式突破傳統構思的工藝作品發揮創新又細膩能量嶄露於眼前，生活化的工藝美學在此平臺上聚合交流，激盪出更多精彩的文化創意動能。

　　「天工」大展就是要喚起眾人對於職人的重視。過去被忽略的職人精神，其意義就是文創的靈魂，工藝匠人都是用盡全心全意，投入專注力、意志力及持續力成就一件事，體現在民藝、信仰以及生活習慣，彰顯百年執著不懈的職人魂。藉由「天工」大展，期待能牽動更多人願意去親近大地、關愛人群，挖掘且深耕在地情感故事，真正以臺灣這塊土地為感念，為獻上一己之力喝采。深深期勉「走自己的路，心有多大，世界就有多大」，那麼不管我們走到哪裡，都可以順從自己的心，邁向康莊大道，進而締造舉世矚目的良機！

<div style="text-align: right;">國際策展人 </div>

臺北當代工藝設計分館介紹／NTCRI TAIPEI BRANCH INTRODUCTION

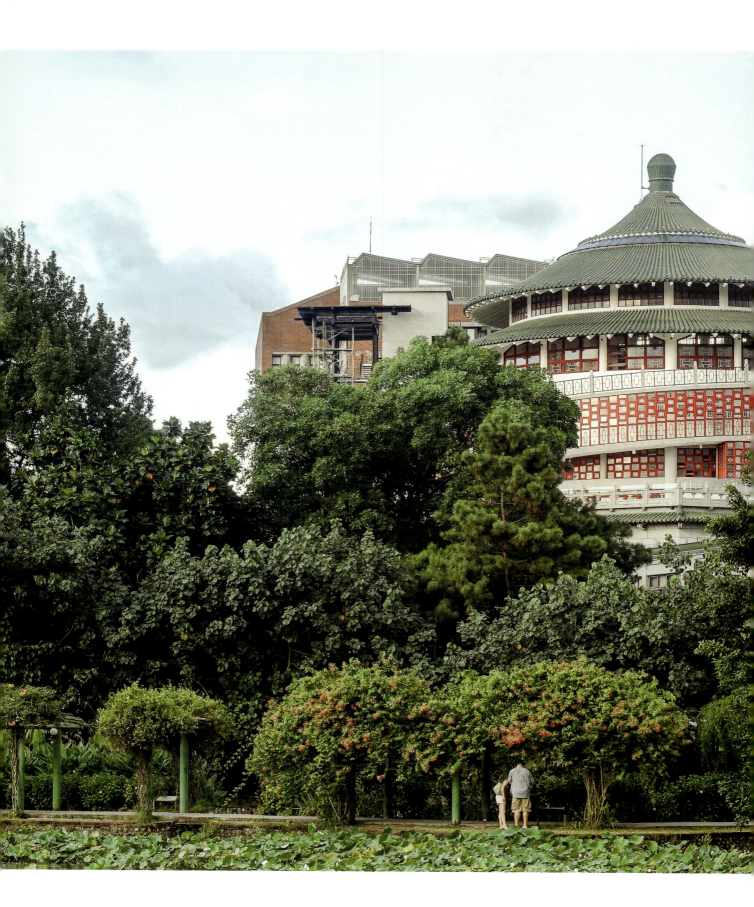

　　國立臺灣工藝研究發展中心 (以下簡稱本中心) 所屬「臺北當代工藝設計分館 (以下簡稱臺北分館)」於 2015 年秋天正式進駐南海學園原隸屬教育部的原「國立科學教育館」。館區週邊蘊含歷史、文化、藝術與教育氛圍，早期即是文人雅士薈萃之地，藝文機構密度之高，不僅傲視大臺北地區，亦堪稱全臺之冠。本中心放眼國際展望未來，試圖為國內的工藝創作者在都會地區打造更優質的展售平臺與更暢通的交流管道，並以此地做為掌握世界工藝趨勢、接軌國際動態的窗口；而臺北分館建築揉合中國傳統與西方思想的特色，恰恰與本中心追求延續與創新的精神不謀而合。

　　光復初期，國民政府遷臺，亟待建立中華文化「民族精神教育場所」。民國 40 年代，由先總統　蔣公責成張其昀教育部長籌設，遂規劃於植物園南區，以中國宮殿式建築風格興築藝術、文化、科學等五個社教機構，包括歷史博物館、教育資料館、藝術教育館、科學館及教育廣播電臺，成為彰顯中華法統延續以及現代化教育推動的象徵。該建築原名為「國立臺灣科學館」，是盧毓駿建築師隨國民政府遷臺後在臺灣的第一件作品，也是實踐其建築理念的代表作。該棟仿北京「天壇」造型的建物經臺北市政府於 95 年 6 月 26 日公告為臺北市「市定古蹟」，並於民國 97 年正式撥予本中心使用，歷經八年的修復整建，終於在 104 年 12 月 23 日正式落成啟用。

　　臺北分館的建築特色是融合中國傳統建築工法與現代西方思想，一至四樓以象徵石材的斬假石牆面形塑厚實沉穩之「臺基」意象，五至七樓以朱紅傳統形式木構玻璃窗與螺旋形坡道形成「屋身」，「屋頂」採琉璃瓦頂塑造寶頂意象。正面以大型階梯直上 2 樓搭配正門上方出挑的木構樓閣，模擬向上朝觀的入口意象，四周環繞以仿石望柱鉤欄，整體呈現出中國北方「官式建築」風格。在攢尖重簷頂、橫樑彩繪、木造窗櫺、琉璃瓦、戧脊及仙人走獸與獸首，還有仿清制水泥欄杆等中國建築語彙的環繞包覆之下，建物的內裝卻富涵西方現代思想的意趣，如二樓通往三樓的螺旋梯和五至七樓的戶外迴廊，不但反映出柯意比的影響，也浮現了古根漢美術館的蹤影。

　　臺北分館以成為臺灣當代工藝、設計及文化之國際交流平臺為重要使命，積極推介青年工藝家參與國際競賽、駐村及交流展覽，並辦理國內外工藝競賽活動及展售臺灣特色工藝精品，為臺灣工藝的發展提供展覽、銷售、教學、集會、行政及資料查詢功能。全棟九層樓的古蹟建物設有戶外廣場、行政辦公室、展覽空間、工藝精品展售空間、工藝家進駐工坊、餐廳、工藝教室、會議廳與圖書室等空間，希冀形塑成為國內文創、工藝、設計等業者的交流聯繫中心，並凝聚相關資源，推動跨界整合發展，以成為「臺灣的當代故宮」自我期許，讓當代最好的工藝作品有一個完善的展演空間與互動、交流的舞臺。

國家圖書館出版品預行編目(CIP)資料

天工：當代工藝的百工百貨 / 郭哲旭主編. -- 初版.
-- 南投縣草屯鎮：臺灣工藝研發中心，民 105.01
　　面；　公分
ISBN 978-986-04-7916-4（精裝）
1.臺灣傳記　2.工藝　3.作品集

960　　　　　　　　　　　　　　　　105001064

天工 當代工藝的百工百貨

指導單位	文化部
主辦單位	國立臺灣工藝研究發展中心
出版發行	國立臺灣工藝研究發展中心
地　　址	南投縣草屯鎮中正路 573 號
電　　話	049-2334141
傳　　真	049-2356613
網　　址	http://www.ntcri.gov.tw
發 行 人	許耿修
策　　劃	陳泰松
主　　編	郭哲旭
執行編輯	盧純鶴
策　　展	陳俊良
文　　字	蘇于修
美術編輯	自由落體設計
攝　　影	張志清 / 王子維
翻　　譯	曾偉禎 / 涂淑愛 / Chris Huberstey / Sara Huberstey
印　　刷	博創印藝文化事業有限公司
出版日期	中華民國一〇五年一月（初版）
I S B N	978-986-04-7916-4（精裝）
G P N	1010500117
工 本 費	新臺幣 800 元